M000002646

Forgotten Tales of
Long Island

to GraNDpa

from Gabriel

and

Daniel

11712008

happy

Brth Day

Forgotten Tales of
Long Island

Richard Panchyk

Charleston London

the
History
PRESS

Published by The History Press
Charleston, SC 29403
www.historypress.net

Copyright © 2008 by Richard Panchyk
All rights reserved

Cover and illustrations by Marshall Hudson.

First published 2008

Manufactured in the United Kingdom

ISBN 978.1.59629.381.6

Library of Congress Cataloging-in-Publication Data

Panchyk, Richard.
Forgotten tales of Long Island / Richard Panchyk.
p. cm.
ISBN-13: 978-1-59629-381-6 (alk. paper)
1. Long Island (N.Y.)--History--Anecdotes. I. Title.
F127.L8P36 2008
974.7'21--dc22
 2007046231

Notice: The information in this book is true and complete to the best of our knowledge. It is offered without guarantee on the part of the author or The History Press. The author and The History Press disclaim all liability in connection with the use of this book.

All rights reserved. No part of this book may be reproduced or transmitted in any form whatsoever without prior written permission from the publisher except in the case of brief quotations embodied in critical articles and reviews.

ACKNOWLEDGEMENTS

Thanks to the indispensable Saunders, Shawna and Brittain at The History Press for their support and encouragement. Also thanks to my family for their good humor and patience.

INTRODUCTION

Presented here is a collection of odd, quirky and mostly forgotten true stories from throughout Long Island's long and fascinating history. Most of these vignettes are from what are now Nassau and Suffolk Counties. Some of them take place in present-day Queens County (of which Nassau County was a part until Queens was annexed by New York City just before the turn of the twentieth century) and Brooklyn (also considered part of Long Island until annexed by New York City). These little stories are interesting both as social commentary and as forgotten history. I have culled them from numerous period sources, including newspapers, books and historical records.

I have enjoyed reading exactly this type of book since I was a kid. In fact, the first piece of writing I ever sold was a four-page trivia booklet I wrote by hand in leaky blue ballpoint pen on a piece of loose-leaf and sold to a thoughtful third-grade classmate for a nickel. As I grew older, I perused fact books, record books and almanacs religiously. For my college newspaper I compiled with relish brief news stories, odd items about train wrecks, storms and other occurrences from around the country.

Naturally, this book was a delight to write.

I hope that the reader has as much fun with this book as the writer did.

COMBINED, IT ADDS TO 205

It was reported that a former slave named Peggy Case died in Greenport on October 11, 1870, at the ripe old age of 103. Her husband Jason, also a former slave, had died eight years earlier on Shelter Island. He was 102. The couple had lived there in relative poverty for 50 years. Because they were so poor, in 1860, Jason Case had still been providing his services as a farm laborer at the age of 100.

THE SCORE IS RED BALL TO BLUE BALL

Warren Augustus Browne of Hempstead thought he had a good idea. In fact, he thought he had an excellent idea. He applied to the U.S. Patent Office in 1889, and on September 30, 1890, United States patent number 437,562 was granted to him for his invention of a new scoring device for baseball games. Browne claimed that this invention would make it easy for spectators of any intelligence level to see the score. The contraption consisted of a tubular socket and pole driven into the ground. It utilized red and blue blocks affixed to the pole to show how many runs each team scored in a particular inning. A system of pulleys was used to hoist the blocks into place. If a team did not score, a special striped block could be used. It is no great shock that this invention never quite caught on, losing out instead to scoreboards that had actual numbers on them.

THE HORSES MADE IT

On a Wednesday evening in March of 1854, a severe thunderstorm passed through the Huntington area. A local paper mistakenly called it a hurricane. Though it did not last very long, the wind and heavy rains caused heavy damage, especially in the Melville (also known as Sweet Hollow) area. Emerging from his house after the monsoon, farmer Daniel Baylis of Melville was dismayed to find his barn and an adjacent building blown almost completely down, its debris instantly burying four horses and three cows. The horses were buried alive under several tons of hay. It took some effort and several hours, but Mr. Baylis and his neighbors managed to dig the horses out alive, though badly injured. It was not reported how the cows fared.

The Disappearing Corpse

An unfortunate black cook drowned off the steamship *Vicksburg* near Fire Island in the winter of 1874–75. His body was soon recovered and transported back to land by a nearby ice boat. Well, almost. It seems that the ice boat lost the cook's body into the chilly waters on its way to the shore. Nothing more was seen of the drowned cook until the body was rediscovered by a man named Norton Jones in August of 1875, near where the poor man had originally drowned. Mr. Jones placed a buoy to mark the body, and hurried off to get help in recovering it. When he returned, the body had disappeared again, floating away in the current.

Two Plane Crashes in One Day

In November 1929, a small plane that had taken off from a popular nearby airfield (Roosevelt Field) crashed in the heart of downtown Westbury Village, at the intersection of Post Avenue and Maple Avenue. The plane smashed into the porch of Daniel McLoughlin's real estate business, and the twisted wreckage of the plane wound up in the center of Maple Avenue. Miraculously, only the pilot, James Pisani, was killed. Not two hours later, another plane crashed, this time in the neighboring village of Carle Place, less than two miles away from the site of the first crash. In this case, the aircraft was a

large Fokker thirty-passenger craft. The plane crashed into the home of Arthur Wicks on Jamaica Avenue and destroyed it. The neighboring home of Joseph De Biever was also set ablaze and destroyed. Even though there were children playing on the street nearby at the time of the crash, nobody but the plane's pilot, S. Marshall Boggs, was killed. Thousands of spectators were drawn to the site. Following the accident, Captain Eddie Rickenbacker, American flying ace and hero of World War I, visited with those whose homes had been destroyed.

SING WHEN THE WAR ENDS

A little-remembered war between the French and the English took place in the 1740s. Called Queen Anne's War, it had Long Island colonists nervous about a possible menace by French ships. At that time there were 614 men from Suffolk County in the provincial militia, along with 601 from Queens and 280 from Brooklyn. When the French surrendered in July 1745, there was quite a celebration. As reported from Jamaica in the *New York Weekly Post-Boy* on July 20, 1745:

> *The Good News of the Surrender of Cape Breton coming to us in the Middle of our Harvest obliged us to defer the Time of Publick rejoicing until yesterday: when the Magistrates, Military Officers and many other Gentlemen &c. of this County met at this Place and Feasted together, and at night gave a Tub of Punch and a fine Bonfire, drank the publick*

Healths and especially of the Valiant commander immediately concern'd in this great Action, and joined in Chorus to the following Song,

> "*Let all true subjects now rejoice*
> *The seventeenth day of June*
> *On Monday morning in a trice*
> *We sang the French a tune.*
>
> *A glorious Peace we shall have soon*
> *For we have conquer'd Cape Breton*
> *With a fa-la-la!*
>
> *Brave Warren and Pepperell*
> *Stout Wolcott and the rest*
> *Of British Heroes with Good Will*
> *Enter'd the Hornet's Nest.*
>
> *A glorious Peace &c.*
>
> *A Health let's to King George advance*
> *That he may long remain*
> *To curb the Arrogance of France*
> *And Haughtiness of Spain.*
>
> *A glorious Peace &c.*"

Horse Races and Other Amusements

Horse races were quite popular in colonial days on Long Island. The Hempstead Plains, a great flat expanse near present-day Uniondale, Garden City and New Hyde Park, was seen as the perfect locale. In the 1660s, the British governor of the New York colony laid out a horse racing course there. He offered a valuable silver cup to the winner of the annual race; the March 1668 silver cup is still in existence and is one of the oldest existing racing trophies in the world. Racing continued on the plains for hundreds of years. Many truly massive races were run there over the years. For example, a great horse race was run on the Hempstead Plains on the first Friday of May in 1750. Dozens of spectators came all the way from Manhattan, taking seventy chairs with them across the East River on the Brooklyn ferry. Numerous horses were also transported on the ferry. It was estimated that the total number of horses at the races that day on the plains exceeded one thousand. Other fun activities of the eighteenth century included bull baiting, an activity that was advertised in 1774 as taking place in Brooklyn Heights every Thursday at three o'clock.

A Lamb a Year Keeps the Mortgage Paid

Gardiner's Island was purchased in 1639 by Lyon Gardiner, who bought an Indian claim to that land for some blankets,

a gun and bullets, a dog and some rum. At first he paid a sum of five pounds annually to the British Lord Stirling. The price was later reduced to one lamb per year.

Don't Tell Them about the Whale until Monday

In 1644, Southampton passed laws pertaining to whales that washed ashore on the town's beach. The regulations said that the spoils of the whale must be shared among the townsfolk rather than be awarded only to the finder. The regulation provided that the discoverer of a beached whale would receive five shillings for his efforts, unless the magistrate or other appointed official decided it was not worth five shillings, in which case the finder would get nothing. According to the laws, anyone who found a beached whale on Sabbath day was also out of luck and would get nothing.

Strike Three and Goodbye

Over the years, countless thousands of baseball players have dreamed of playing in the big leagues. Only a few have ever seen their dreams come true. Frank Norton (1845–1920), a native of Port Jefferson, saw his dream come true on May 5, 1871, when he made his Major League debut for the Washington Olympics of the National Association. Unfortunately, in his only at-bat, Norton struck out. A third

baseman, he also made a fielding error that day. He never played in another Major League game again.

WHIPPER SNAPPER

In olden times, whipping was a common punishment for various infractions. For many years in Easthampton a whipping post was set up. In 1727, R. Syme was voted as the town's "common whipper" and was paid three shillings for every person he whipped.

A QUAKER'S SENTENCE

In March 1658, a Southold Quaker named Humphrey Norton was sent as a prisoner to the general court in New Haven, Connecticut. He was tried on several charges, including slander against a pastor, seducing people away from their religions, trying to spread heretical opinions, using blasphemous language, attempting to circumvent the authority of the government and instigating rebellion and disorder with boisterous language and unseemly conduct. He was fined a sum of twenty pounds, and was sentenced to be severely whipped and branded on his hand with the letter "H."

A MOST SEVERE CASE OF MOTION SICKNESS

In 1845 came a strange report of a woman who lived in Bridgehampton. This woman, who was described only by her initials of S.P., was born in March 1778. She had led a normal and active life until one fateful day a few days before her twenty-fourth birthday in 1802. While caring for her terminally ill father, she fell seriously ill and took to her bed. Her doctor gave her an emetic, and its effect on the woman was so severe that it almost caused her death. From that day forward, she could not walk, could not stand and could not even sit up in her bed. She was completely bedridden. If she was moved she vomited violently. She was said to vomit tremendous amounts of a brownish liquid. In fact, in the early years of her illness, the slightest movement of the bed or even vibrations on the floor would set her off. For years her voice was also affected and she could not speak above a whisper. On top of her usual misery, she suffered from dysentery in 1805. Physical therapy was attempted at one point—she was placed in a rocking cradle and a chair swing. These two treatments had such a violent effect upon her that she nearly died from them. When she had to change residences, it was quite an ordeal to move her, one that nearly cost her life. After 1819, she was never again placed into a chair. For years she had no interest whatsoever in food of any kind. Even after her aversion to nourishment passed, she was unable to eat milk, butter or fat- or acid-heavy

foods. Her health improved enough by 1840 that she could turn in bed and was less sensitive to movement, but she still remained completely immobile. Her hands, however, were fully functional, and she tried to keep them busy. To earn money, she learned how to make silk buttons, infants' socks and men's stockings, which she sold for profit.

Amazing Recovery

Also in 1845 came a fascinating report of a man from Sag Harbor. This man, whose initials were E.L., had been born in 1802. As a child, he was bright and ambitious, a good student. As a young teenager, he began to learn the trade of rope making. Things took a turn for the worse when he contracted a severe case of typhoid fever in 1816. During this time, he also had muscle spasms and was unable to walk. For many months, he could only crawl. For some unknown reason, he refused to eat meals in his father's house and for months could regularly be seen crawling nearly five hundred feet to his grandfather's house for food. But he insisted on crawling back to his father's house after eating, for he would not sleep in his grandfather's house. However, after his grandfather died in 1819, he moved in with his grandmother. He lost all consciousness of his prior identity. He also became suddenly deaf. He learned to talk a little, but he called things by strange and incorrect names. He called dollars "junks," referred to church as "school" and called a friend

of his "cakes" and another friend "chestnuts." Friends and family used sign language to communicate with him. Once he recovered the full use of his limbs, he became a ship's hand. He also worked other odd jobs, including making tinware and serving as a joiner. In 1820, after a day spent duck shooting, something strange happened. He recorded the events later:

> *I went to bed with a dreadful pain in my head. In the course of the night, something ran out of my ear. I woke up, and heard the wind blow against the house; and it frightened me. I covered my head and fell asleep. In the morning I was waked by a cat mewing in the hall, and it scared me dreadfully. At length, I got up and went down stairs. My father began to make signs to me to rake open the fire and put on some wood. Said I, father, you needn't make signs, I can hear as well as you can.*

The man woke and was completely cured. He had no memory of the four years he had been sick, only of his life before his sickness. He went on to become a sea captain and lead a perfectly normal life.

A Fishy Fertilizer

The mossbunker, or menhaden fish, was used widely as a fertilizer during the nineteenth century. It was said that the fish, similar in appearance to a herring, could do wonders

for the soil. For fields of grass, 2,000 fish per acre was recommended. For grapes, one was to make a hole with a crowbar and push a fish into the hole near the root of the grapevine. There was a drawback; according to one book of the time: "the abominable and unhealthy stench which poisons the whole country, and, according to the testimony of some medical writers, lays the foundation of dysenteries and autumnal fevers." However, that did not really deter anyone—at Bridgehampton, 84,000 menhaden were taken in a single haul. They were sold for about two dollars per 1,000 fish.

OLD SAMUEL MILLS

In March 1727 was printed an obituary for Samuel Mills, a yeoman from Jamaica. Mills, age ninety-five, had been born in America in the early 1630s. It was said he was a very hard worker, an honest man and had been able to do a decent day's work until a few days before his death. He left behind his wife of sixty-eight years, nine children (out of a total of sixteen), eighty grandchildren and fifty-four great-grandchildren. His wife had given birth to their final child at the age of fifty-one.

WILD ANA ROGERS

In May 1676, John Rogers of Queens County filed a complaint with the colonial governor that his wife Ana had been drawn away by one Thomas Case of Maspeth Kills, in whose home she had been found after being missing for two weeks. It was alleged that Case's "teachings" had led the woman astray. Rogers had tried to get her to leave Case's but she would not go. After her husband's complaint, Ana was brought before the governor at Oyster Bay. After various exaggerated expressions, she promised to return to her husband's, act like a proper wife and never again to stray, particularly after Thomas Case. But the very next morning, she showed up at the door of George Dennis in Oyster Bay. This happened to be where the governor was staying. She

proceeded to appear in a "dancing, quaking manner, with silly insignificant discourse to the disturbance and scandal of the house." She was taken to New York City and locked up.

THE WHALER'S MONUMENT

Whaling was a huge industry on Long Island, but it was also a dangerous profession. A Whaler's Monument was erected in 1856 in the Oakland cemetery in Sag Harbor. The shaft features a broken ship's mast. The monument features a carving showing a sperm whale that struck and wrecked a whale boat. The boat is upside down with three men hanging on for dear life and holding the dead body of a fourth man. On the monument are carved the names and ages of six shipmasters who died between 1838 and 1846, all under the age of thirty. Written on the monument is the following: "To commemorate that noble enterprise, the Whale Fishery; and a tribute of lasting respect to those bold and enterprising Ship Masters, sons of Southampton, who periled their lives in a daring profession, and perished in actual encounter with the monsters of the deep. Entombed in the ocean, they live in our memory."

TRAIN MEETS CAR FOR THE FIRST TIME

A dubious distinction went to Westbury in October 1904, when the rail crossing at Post Avenue became the site of the

first ever train-car crash in the United States. A famous race car driver named Henri Fournier happened to be crossing the railroad tracks in his $9,000 automobile at the speed of just six miles per hour, when he was stuck by an oncoming train. The other five occupants of the car included a newspaperman from the *New York Herald* and one from the *New York Journal*. One was thrown a distance of about fifty feet. An injured passenger later sued the railroad company, but the suit was rejected. Fournier seemed not to be too badly shaken up; he set a new speed record of a mile in fifty-two seconds at Coney Island just two weeks after the accident.

WILD DOG

In January 1832, a wild creature on the loose near Eastwoods caused concern among the residents. Henry Hewlett had an ox bitten by this animal, deemed a "strange dog." The ox died two weeks later. Next Lewis Hewlett lost three cows and John Hewlett lost a dog. The animal was captured, and after being chained nine days and showing no signs of hydrophobia, he was released. The dog ran south to Hardscrabble, then doubled back to Eastwoods and then on to Cold Spring, where he attacked a woman. He then crossed to Babylon and Islip, where he bit many dogs. He was finally killed, to the relief of the local residents, who had taken to carrying clubs around wherever they went.

Alcohol Made Him Fall

In 1879, Sarah Hubbs of Huntington filed suit against Christian Gold, of the Comac Hotel, for having sold alcohol to her husband, George S. Hubbs. Mrs. Hubbs alleged that the liquor caused her husband to become intoxicated, made him vicious and caused him to fall from his wagon, from which he received severe injuries.

Catch and Don't Release

Gilder S. Conklin's hand was badly bitten by a shark in September 1892. The fifty-two-year-old farmer, who hailed from Southold, was on his boat with a boy who was helping him haul in his net. When brought onto the boat, the net was found to contain a shark five feet in length. The boy grabbed the shark's tail as it flailed about on the boat's gunwale. While the shark was in motion, Mr. Conklin's hand was caught in its open mouth, tearing the flesh off the back of his hand. The shark would not let go of his hand until an oar was rammed down its throat. Mr. Conklin recovered well from the incident and lived to the ripe old age of seventy-seven.

A Tough Story to Swallow

In the early morning hours of July 18, 1901, James Anderson, Secretary Jones and Joseph Stern set out from the Ocean Avenue dock at Bay Shore on a fishing expedition. After about two hours at sea, they spotted a huge shark in the waters, which they thought to be about three hundred pounds in weight. Nearby, a baby shark frolicked. As the fishing boat neared the sharks, the mother shark opened its mouth wide, seeming to beg its offspring to jump in rather than be captured by the men. The baby shark obeyed, and the shark closed its mouth and swallowed its child. As the shark closed its mouth, the fishermen's hook was firmly affixed to its jaw. There was a great struggle before the shark could finally be killed and brought into the boat. Once the dead shark was ashore, the men could see the baby still moving about in its mother's body. The men wrapped the shark in burlap and shipped it off to the editor of the *Argus*, a magazine of the time.

The Hermit Woman

In 1870, it was reported that an old woman hermit lived along a small lake called St. John, near Cold Spring Harbor. She had located a site along the water's edge, and used two trees that had grown together to form her home, along with some planks, saplings, dried leaves and straw for the roof.

She got water from a nearby spring. She had lived there for years. Nobody knew when or why she had become a hermit, or where she had originally come from.

This Pot of Gold Wasn't over the Rainbow

In April 1879, a young man in Amityville was digging a posthole when he struck a strange object with his spade. When he investigated, he found what he believed to be a large pot of gold, worth at least $50,000. His companions advised him to leave it there until such time that he could remove the treasure without fear of being discovered. They put a post in the hole to mark the spot. Someone else, who had seen the whole thing, dug up the pot and removed it before the men could return the next morning. The young man was dismayed to find a pair of boot prints in the ground near the posthole. Upon investigation, the man found the person who had removed the treasure. The rival did not deny taking the gold, but instead claimed he had discovered it first. The thief offered a trivial amount to settle the matter, but the discoverer refused it. The thief then had the audacity to show off some of the ancient coins that were part of the buried treasure. This only succeeded in making the young man angrier. He threatened to go and report this incident to the proper authorities, when the thief and the other men who had been with the finder told him the whole thing had been a fake, and that they had buried the pot themselves as a practical joke.

CAPTAIN KIDD'S BURIED TREASURE

In May 1699, the notorious pirate-hunter turned pirate
Captain William Kidd had just returned to North America
from a successful raid of an Arabian ship called the
Quedagh Merchant. He was on his way to Boston when he
heard rumors that he was a wanted man. He anchored his
ship *San Antonio* just off Gardiner's Island and remained
offshore for a couple of days. John Gardiner, grandson of
the original owner of the island (Lyon Gardiner), went out
to the ship to see what was going on. He was brought to see

Captain Kidd, who asked for a few sheep and some cider. Gardiner felt he ought to oblige and filled the captain's requests. Kidd then sailed away, but soon returned, having decided to bury his treasure on the island for safekeeping. He buried the treasure under an old oak tree and swore John Gardiner to secrecy, telling him that if the treasure wasn't there when he came back, Gardiner would pay with his life. All Gardiner received as thanks was some sugar, which, though scarce, was hardly a treasure. Some of Captain Kidd's crew also entrusted their possessions to Gardiner, who received some stockings for his trouble. Shortly after he arrived at Boston, Captain Kidd was captured and thrown in jail. The authorities wanted desperately to know where the treasure was. Finally Captain Kidd relented and told them that John Gardiner would be able to tell them where on his island the treasure was buried. They immediately sent for Gardiner. Since Gardiner wanted to cooperate and avoid being connected to Kidd, rather than go empty handed, he went to the secret spot, dug up the treasure and brought most of it with him to Boston (he left behind some quilts and fabrics). The treasure included 1,111 ounces of gold, 2,353 ounces of silver, 17¾ ounces of rubies, exotic fabrics and a bushel of nutmeg and cloves. Seized from Kidd's ship were 57 bags of sugar. When Gardiner returned from Boston, legend has it that as he unpacked his travel bag, a beautiful diamond dropped out. He determined to send it off to Boston, but his wife told him to keep it after all the trouble Captain

Kidd had caused him. Kidd was deported to England, where he was eventually tried, found guilty (not of piracy but of murder) and hanged in 1701. Part of the captain's Gardiner's Island treasure was sold at auction in London in 1700 and brought a price of about £6,500.

BACKWARD SKATING

Henry T. Davis, native of Islip, was quite an ice skater. In one instance in February 1893, he was spotted skating at Central Park in New York City. It was said that when Davis was skating backward, two experts skating forward in normal fashion could not catch up with him. His fancy display drew such a crowd that police had to intervene to scatter them more than once. "Who is that fellow?" the curious onlookers would ask. The annoyed police would reply that he was just "a chap from the country."

RABBIT DOG

Nathan Conklin, of Huntington, spent his time breeding English hares for sale in New York City. One day in 1893, one of his best rabbits got loose and ran away. Conklin was inconsolable over the loss of this animal. His large Newfoundland dog sensed what was wrong, and bounded across the fields and on into the neighboring forest. After

a few hours, the faithful dog returned with the missing rabbit in his mouth. When Conklin examined the hare, to his great joy, not a scratch was found on the escaped rabbit.

A HORSE FINDS RELIGION

All of God's creatures are blessed. Apparently, some actively seek this blessing. In June 1894, a runaway horse at Islip galloped into the Presbyterian church, where the doors were wide open. Its journey ended there, as it next collapsed into a heap among the pews, several of which were demolished in the process.

COULDN'T BELIEVE IT WASN'T BUTTER

In June 1894, thirty-year-old Everett Penny of Eastport was brought before Justice Heyman of Patchogue by an inspector of the State Agriculture Department. He was found guilty of selling margarine as butter and was fined fifty dollars. Others were also brought before Justice Heyman on the same count and were fined twenty-five dollars. Apparently, dairy-related crimes were considered quite serious in those days.

VINTAGE 1765?

Though the popular belief is that grape growing on Long Island is a very recent innovation, records show that Joshua Clark and Francis Furnier of Suffolk County grew grapes on the east end of Long Island hundreds of years ago. Between the years 1762 and 1767, Clark set out 3,200 vines and Furnier set out 1,551 vines. They were awarded a certificate of recognition by the newly formed New York Agricultural Society. While Thomas Young of Oyster Bay received a ten-pound premium award for his orchard of 27,123 apple trees, Clark and Furnier received only a certificate because nobody at the time thought grape growing possible on Long Island, and so a prize had not been set up for that crop.

NO EXPIRATION DATE

About three miles south of Huntington village, in a settlement then called Long Swamp, lay many fine springs of cold and refreshing water. In replacing a trunk pipeline to one of these springs in the early nineteenth century, a tightly corked glass bottle was unearthed. From the looks of it, the bottle was many years old, and had been deposited by some previous generation. When it was opened up, it was found to be filled with milk, which was said to be perfectly fresh and sweet.

The name of the person who was adventurous enough (and perhaps foolish enough) to taste the milk was not reported.

Did He Have Reservations?

For most of us, a two-week stay in the same hotel is a long time. For Austin Roe, hotelkeeper extraordinaire in Patchogue, two weeks represented the longest time he was ever *away* from a hotel. Roe was born in the Patchogue Hotel in 1807, and by 1892 still resided there at the age of eighty-five. He believed himself to have lived in a hotel longer than any other man on the face of the earth.

I'm No Rabbit!

Ernest Grauz was a proprietor of the nursery firm of Sowehl & Grauz in Hicksville. One morning in late December 1892, he was out among the plants in the nursery when he heard a gun go off and was shocked to see shot spray around him. Then, that afternoon, he was back out in the nursery when he heard another gunshot. This time, he was not so lucky. He was hit in the face and hands by shot and was bleeding from his wounds. A total of twenty-three pieces of shot were removed from his neck, face and hands. He imagined the incident to be the result of some careless rabbit hunters who had come to Hicksville from the city.

Fox Hunt Frenzy

In 1893, it was reported that there were more foxes on Long Island than ever before. Ironically, the finger of blame was pointed at the many hunting clubs that had sprung up around the island during the late nineteenth century. Because many of the foxes used in their hunts successfully eluded the dogs and their mounted hunters, the foxes were able to multiply quickly and cause damage to many a farmer's stock.

Have You Been to Old Man Lately?

Long Island has always been a location with interesting place names. Many have changed since colonial days, though some have remained. Names that could be found include Gunnunks, Merosuck, Feversham, Susco's Wigwam, Seal Island, Mosquito Cove, Horse Neck, Old Man, Great Cow Harbor, Turkeyville, Modern Times, the Branch, Scuttle Hole, Hermitage, Marathon, Christian Hook, Farmers Village, Drown Meadow, Snake Hill, Slongo, Bungy, Hard Scrabble, Hungry Harbor, Wastelands, Hog Island, Bread-and-Cheese Hollow, Fireplace, Canoe Place, Goorgo, Compowams, Copwax, Dickepechegans, Hocum, Nipscop, Nosh, Poosepatuck, Punk's Hole, Quanch, Qualican, Rungcatamy, Screcunkas and Skookwams.

HAPPY FIFTH ANNIVERSARY

Mr. and Mrs. Peter Luyster of Glen Cove were married in 1871. They received as a wedding present a set of silver from their friends. It was a nice gift, attractive and practical, and worth one hundred dollars. They placed the gift in a room on the second floor and went about their party. As the couple and their guests enjoyed their wedding reception, they did not notice that someone had absconded with the silverware. It was a most distressing development on an otherwise fine day, and a reward was offered for the return of the items, but to no avail. In March 1876, a workman tending a garbage fire in an open field in the vicinity kicked some dirt and caught his foot on something in the ground. He dug farther and found buried there a box containing the missing silverware that had been stolen five years earlier.

A CRUSTY OLD DISH

In the olden days, a popular Indian dish was called samp porridge. To make this meal, you first had to create a mortar and pestle to pound large amounts of corn. The mortar would be made from the hollowed out stump of a large tree. The pestle would be carved from a solid block of wood, which was then attached to a sapling, providing some spring for easier pounding. The crews of ships passing through nearby waters could hear

the pounding of the corn even from afar. The pounded corn was called samp. The samp was then boiled with salted beef and pork, as well as potatoes and some vegetables. It is said that every time the samp porridge was reheated, it tasted better and better. That worked out well because when the dish was made, it was made in large enough quantities to last up to a week. By the end of the week, the re-cooked porridge would form a thick crust along the edges, such that the entire mess could be picked out of the kettle, quite literally lifted out by its crust, and the tender insides eaten as if from a giant bowl.

How Old?

An African American man died in Smithtown in 1739, at the reputed age of 140 years. He had said he remembered when there were only three houses in New York City. In fact, the first Africans had arrived on Manhattan Island in 1626,

two years after Europeans first settled there. By that point there were more like thirty homes in New York (then called New Amsterdam); but at the great age of 140, who can blame the man if his memory was a bit faulty?

A Strange Reptile

In September 1801, a very strange reptile was killed in a Hauppauge swamp. The discovery of the beast caused quite a commotion among the locals, because it was of a species quite foreign to that place. The creature was seven feet long and quite thick. Its belly and sides were the color of straw, and along its entire back, from head to tail, was a series of thirty-six black spots. This line of spots was accompanied on either side by other, brown spots. The curious reptile seemed not to have any fangs or teeth, so it was not believed to be venomous. In its mouth was a large, tongue-like piece of flesh with a long forked projection at the end. It had three hundred scuta on its belly and tail. After closer investigation by the locals, it was determined to be of the genus *boa* and the species *constrictor*. Though shocked at the size of the beast,

the locals were surprised to find that these creatures, in their native India, could grow to thirty feet in length.

HUNGRY ENOUGH TO EAT A HORSE

Around the turn of the twentieth century, there were three large horse-slaughtering businesses in Nassau County at Franklin Square, Valley Stream and Elmont. The Elmont establishment, run by a Mr. Roeper, was reputed to be selling the horse meat for human consumption. Mr. Roeper vehemently denied it, claiming the meat was sold only for use as dog food, a practice that he had since stopped. He claimed that he was only selling the skins for three dollars each, and burying all the bodies of the slaughtered horses. When authorities investigated, they found an open field near his establishment, where a great pile of horse meat, cut into small pieces, was laid out to dry. An old man from Maspeth, Queens, oversaw the drying process and carted away the dried flesh for use as fertilizer. The stench of this rotting horse flesh was so great it was said to be detected even among the fragrant flowers of Floral Park, two miles distant, on days when the wind was blowing in that direction. The state health board ordered Roeper to clean up or close up, much to the relief of the citizenry of Elmont.

Bad Luck Charlie

Charles Albin of Eastport suffered a series of bizarre mishaps in 1897 to 1898. In those years, he was on a sailboat that capsized in rough waters off Speonk, and had to be rescued from the rough seas. That same month, he fell in the water with a wagon wheel he was rolling and became trapped in its frame, requiring help to avoid drowning. In April 1898, he claimed to have been badly attacked by a wild muskrat while riding his bicycle in East Moriches. The animal left his clothes in tatters. In July 1898, he was driving a wagon when the horse became frightened and ran away. He gave chase, dashing madly after the creature until it crashed through a barbed wire fence and was stopped. In yet another incident, Albin had just strategically placed some new duck decoys when another hunter spied them and fired both barrels of his shotgun. Albin, who was crouched near his decoys at the time, was hit by the shot. Luckily for him, he happened to be wearing a heavy coat made of canvas, and the shot did not penetrate it.

A Whale of a Whale

In February 1907, a fifty-four-foot-long whale was captured and killed near Amagansett on the East End of Long Island. At the time, it was said to be the largest baleen whale ever recorded. The skeleton was sent to the American Museum

of Natural History in New York City and was finally put on display in 1934, after years in storage and preparation. A baby of the captured whale had also been spotted and was later killed. It measured thirty-eight feet in length. Its bones were traded to a British museum for a dodo's skeleton.

WENT BLIND CUTTING WOOD

It was reported in 1876 that John Jackson, living in Good Ground, Suffolk County, was likely the oldest man on Long Island. Born in Riverhead in 1775, Jackson was exceptionally healthy and hardworking, even up to the age of one hundred. He was proud of the fact that he never smoked or chewed tobacco. A few months previously, he had been out chopping wood in the forest when he suddenly and without explanation went blind. Robbed of the ability to see, he could not find his way back home, and so resolved to spend the night in the woods. He was rescued the next morning by some friends, apparently none the worse for it.

ARMY WORM ON THE MARCH

In 1852 came a report that a plague of army worms (actually the larval state, or caterpillar, of a night-flying moth known as *Leucania unipuncta*) was attacking crops on Long Island. Everything from wheat to oats to barley was being attacked.

It was said that an entire field could be ravaged in a few hours and up to ten acres could be destroyed in a single night. Especially hard hit were Southampton, Sag Harbor and Bridgehampton. During the nineteenth century, there were several recommended methods to defeat the army worm. One suggestion was to plough a steep furrow around the crops. The "marching" worms would fall in and be trapped. Straw could then be laid into the furrow and set ablaze, though this could be dangerous to nearby crops. Another suggested method was to run a heavy iron roller over the field the worms were invading and crush them to death. A third suggested method was to set loose some hogs, chickens, ducks or turkeys and let them feast on the pesky caterpillars.

FORGOTTEN TALES OF A SUPERMAN

In the 1950s and 1960s, there lived in Brentwood an unassuming man named Bill Panzen. How many of his neighbors, watching him mow his lawn or bring groceries inside from his car, could imagine the illustrious career of his youth? He had been a professional wrestler in the 1930s, losing only four matches out of a total of seven hundred. He had beaten sixty-five champions, and been featured in the "Ripley's Believe it or Not" comic strip. He was profiled in *Strength and Health* magazine's "Supermen" feature. In 1939 and 1940, he had been voted the number one wrestler in

America. Some of his biggest matches had been refereed by the likes of Jack Dempsey, Max Baer and Joe Louis. He was proud to have never taken a fall for anyone, and was a promoter of "clean" wrestling. He had also been active in weightlifting, winning fifty-five tournaments and qualifying for the 1936 Olympics. He had also served as a weightlifting contest referee and announcer. He had founded several athletic clubs, and fitness-trained more than six hundred athletes. He had played semiprofessional football for several teams in New York, Minnesota and Texas. He had also been the publisher of a fitness magazine called *All-American Athlete*, as well as the author of numerous fitness, weightlifting and wrestling articles and columns. He had accomplished all of this before his twenty-third birthday.

The Case of the Phantom Burglar

In 1936, a so-called "ghost" or "phantom" burglar hit several estates on Long Island's North Shore. The burglar entered estates late at night, through porches or windows, often knowing exactly where to look for money and jewels. Some outings were more successful than others for the phantom. In robbing the Locust Valley home of John W. Davis (1924 Democratic presidential candidate) in September 1936, the phantom for some reason only got $5 in cash. When he entered the home of Winthrop Aldrich in Wheatley Hills, he was able to take cash and jewelry worth $3,500. Another

$20,000 was taken from the home of Mrs. Irving Cox in June 1936. The phantom's biggest single take was at the Coe estate in Planting Fields, where $400,000 in jewels were taken, including an exquisite pearl necklace worth $300,000 alone.

DUCKS APLENTY

Long Island has been known for its duck farms for many years. In one week in 1925, Long Island sent fifty-six thousand ducks to market in New York City in time for the Feast of Tabernacles, a Jewish holiday. The finest of these brought thirty-two cents per pound at market.

NO KIDDING, CAPTAIN?

There are various versions of the story of when the notorious Captain Kidd landed at Gardiner's Island in 1699. One version has Kidd ordering Mrs. Gardiner to roast a pig for him. She dared not disobey, so she did as he told her. Another version of the story has Mrs. Gardiner sending over two live oxen for Kidd and his pirate crew to barbecue, figuring if she didn't he would have just taken them anyway. In one version of the aftermath, he was pleased with the food and presented Mrs. Gardiner with a silk altar cloth interwoven with genuine gold threads. In another version of the story,

he tried to present her with a reward, but she declined to accept it. By this account, Captain Kidd thought about stealing a few pigs from some nearby Connecticut town and giving them to Mrs. Gardiner. He thought again, deciding he wanted to find some other way to reward her that would not require him leaving and returning. Instead, he decided to place an expensive diamond, plunder from one of his previous pirate excursions, in the bottom of a well bucket on the Gardiner property. Not too long after Kidd set sail, Mrs. Gardiner's little daughter was sent to the well to fetch a pail of water. According to the story, the little girl saw a sparkle in the bucket and, thinking it to be nothing more than a drop of water, lowered the pail into the well. When she raised the bucket up and the sparkle was still there, she called out anxiously for her mother. Mrs. Gardiner removed the "drop of water" and found it to be a diamond. She soon remembered seeing Captain Kidd stop for a moment at the well on the way to his ship, and she thus figured out what had happened. Still another version of the story has Captain Kidd dropping a diamond into a pitcher of cider from which one of the Gardiner servants had served him.

COWS HELPING COWS

Farm animals, though nearly always penned or fenced in, do not always stay put. In June 1879, Dr. Rainey of the village of Ravenswood had just such a problem with his cow.

The said cow had entered the yard of St. Thomas' Church. Unfortunately, her next move was to keep going and attempt to clear a high wooden fence that separated the churchyard from the street. The cow's front feet successfully reached the ground on the street side of the fence, but the rest of her was stuck on the sharp rail of the fence, which pressed on her stomach just in front of her udder. Two of her cow friends sauntered over to assist. They stood by her head, positioned

their horns under her neck and tried to lift their fellow cow out of her painful position. Finally, the driver of a coach that happened to be passing observed the comical sight and came to the stuck bovine's rescue by tearing down a part of the fence.

SHOOTING MORE THAN THE BREEZE

Shooting ranges can be dangerous, especially when they are near residences and farms. In 1907, the Queens County Grand Jury investigated several complaints of stray bullets flying throughout the area surrounding the Creedmoor Park shooting range. One woman was struck by a bullet and was hospitalized for several weeks. Another woman just narrowly missed being hit by a bullet. A farmer on an adjoining property said he and his friends had collected 150 pounds of spent bullets from his property. A farmer named Frank Franklin had a similar problem on his farm near Little Neck Road. One of his horses was hit by an errant bullet and died. A man named John Hendrickson, who lived a half-mile from the shooting range, reported finding several bullets in his home over the past few years. It was expected that a total of forty witnesses would be called before the grand jury to report their experiences.

Roll Call

In 1840 there were 5,473 horses and mules, 22,236 head of cattle, 46,751 sheep, 20,534 pigs, 51 doctors and 12 attorneys in Suffolk County.

If the Poor Can't Have Them, Nobody Can

In the early nineteenth century at Blue Point Bay in the town of Brookhaven, poor people used to support themselves by collecting oysters from the waters both for themselves to eat and to sell for a few pennies. After a while, the town had enough and decided to charge a tax for this activity. They passed a law that said one needed to buy a license in order to legally collect oysters. The town even raised a body of armed men and fitted out a couple of boats for the purpose of patrolling the waters. The boats went on duty until the poor folks were driven off. As soon as this was accomplished, there was not one oyster to be found in the water, just empty shells. Some years later, in 1839, a plethora of young oysters could finally be found again on the floor of the bay. A similar thing happened at Southampton Bay, where the town enacted a tax on collecting oysters, and then the oysters suddenly disappeared from the bay. People at the time wondered whether God had killed the oysters because the poor could not have them.

Starched

Nineteenth-century Glen Cove had the distinction of being home to one of the two largest starch factories in the country. The Glen Cove Starch Works was built alongside Hempstead Harbor in 1855. At first, it produced one ton of starch per day. By 1857, the capacity was up to five tons per day. The complex was destroyed by fire and was rebuilt, and the capacity rose to ten tons per day. By 1868, the Glen Cove Starch Works was producing twenty-three tons of starch every day from a six-story main building. White corn landed at the wharf and was unloaded and then hoisted by steam-powered elevator to the top of the starch works building. It was winnowed to eliminate foreign substances, then soaked in vats and run with water through troughs to the mill, where it was ground. The grinding mechanisms were large stones and iron rollers propelled by a 160-horsepower engine. The starch was then separated out. The starch was sent to vats in the basement of the building and the water was removed. The starch was dried on brick shelves, and then further dried in a kiln and subsequently boxed. The company also made Maizena, a trademarked starchy invention also made from corn that was used in pudding, custard and ice cream.

DON'T EAT THIS FISH

The mossbunker, otherwise known as the menhaden, is usually used as a bait fish. Small and bony, its flesh is extremely oily and once killed it spoils fast. It has never been deemed fit for human consumption—that is, until Mr. J.H. Doxsen of Islip came along. Mr. Doxsen had a canning operation that was already canning other foods. In 1872, he began to can mossbunkers in earnest. His operation used a five-horsepower steam engine and employed up to twenty people to operate the machinery and oversee the process. His machines scaled and cleaned the fish, then cooked and packed them in two-pound tins. According to a review of the time, the meat of this fish was exceptionally sweet, and the fish was cooked in such a way that the many bones (except for the backbone) were edible, such that one could barely notice they were even present.

SHOOT TO KILL IF YOU WILL

Long Island was under British control during the Revolutionary War, and their mercenaries, German Hessian soldiers, were everywhere too. One evening, Jacobus Monfort of Long Island, hearing a noise in his cow yard, fired in the dark and wounded a Hessian baker in the neck. He was seized at once and was taken before a British officer.

Though Monfort must have feared for the outcome of this confrontation, the officer dismissed him at once, saying, "If you had killed him, I'd have given you a guinea."

THE BEST ASPARAGUS

In 1865, Oyster Bay was said to have asparagus so superior in size and tenderness that demand far outweighed supply. The price for Oyster Bay asparagus was twenty-five to fifty cents per bunch, compared to fifteen to thirty cents for asparagus from elsewhere. Several growers visited Oyster Bay to try to figure out why Oyster Bay farmers had such success, but to no avail.

RAISING THE DEAD (WHALES)

Whaling was big business for Long Island in the nineteenth century. Whalers were always looking for ways to be more efficient. Thomas W. Roys of Southampton invented several devices during the 1860s, including an "improved rocket-harpoon" in 1865 and a shoulder-held harpoon gun in 1861. In June 1862, he received a patent for his invention titled Improved Apparatus for the Raising of Dead Whales to the Surface of the Water. This invention featured a ten-foot-long, two-hundred-pound barbed instrument he called a "whale raiser" that was thrust into the whale, which was then raised to the surface.

CHASING A NAKED GHOST

There were several reports of creepy cries and ghostly groans coming from the swampy land between the Mount Olivet and Lutheran Cemeteries in Maspeth, Queens, in July 1884. The voice was first heard by a group of women picking peas. At first, their curiosity led them toward the voice, but when it was clear that the noise was not of this world, the frightened women ran away to a nearby farmhouse. The farmer, W.H. Ring, believed their story and called for the assistance of the local policeman, a man named Bosch. The policeman had already heard rumors of this ghost, who was alleged to appear in the form of a tall, naked man. Ten men were soon gathered to investigate, but most of them chickened out as they arrived at the cemetery near sunset. They convened at a local saloon, and with a few drinks, they were emboldened. They also attracted more volunteers, and so it was a band of fifty men armed with shotguns who ventured into the dismal territory around midnight. They crept cautiously through the darkness. Before long, they could hear the moans quite distinctly. As they moved forward, so did the voice. They could never seem to catch up with it, try as they did. After a mile, the voice ceased and the men gave up their quest. The next night, a similar search party went off bravely but did not find anything either.

Hotel Blues

It was a very bad summer season at the Massapequa Hotel in 1897. First, there were several weeks of wet weather. Guests, frustrated by the rains that never ended, left in droves. Then there was an outbreak of the whooping cough that sent guests fleeing the hotel. Finally, there was a fire that destroyed some of the hotel's sheds. The lessee of the hotel, Ebenezer Rogers, apparently had lost a lot of money on the deal. He killed himself in early September, just a few days before the end of the season. It was not the first time the hotel had ruined someone. When first built in 1893, the hotel financially destroyed the builder, Thomas Brush, and had to be sold at auction.

Brits, But No Blubber

The *Meridian*, a British ship on its way to Sydney, Australia, was blown around by a gale in August 1853 and ran aground on a desolate island in the Indian Ocean. Three people, including the captain, died in the wreck, but the others, including forty-one children, made their way to shore. A whaling ship, the *Monmouth*, originally from Cold Spring Harbor, Long Island, passed near the island and the captain, a Long Islander named Isaac Ludlow, spotted the survivors' encampment. He wished to assist but another gale blew him too far away to rescue them. He bravely

sailed around the leeward side of the island, sending word to the stranded souls to meet him there for a rescue. A three-day journey was necessary to cross the island, and when they got there, the survivors did not find the ship. Due to rough seas, it took another two days for the *Monmouth* to arrive. The captain proceeded to rescue every one of the survivors, but then had the difficult duty of informing Walter Jones, the underwriter of his whaling voyage, that he had lost an entire season of whaling. He brought the survivors to Isle of France, a seventeen-day journey, from where he wrote to the underwriter, explaining that instead of five or six hundred barrels of whale oil, he had 105 British subjects on his ship. "I think you will exonerate me of all blame when you hear the story of the sad loss of the ill-fated ship and the salvation of the suffering passengers and crew...I think you will feel it a high privilege instead of a loss," he wrote. Whatever the underwriter may have thought, the passengers of the *Meridian* were eternally grateful. "The conduct of Captain Ludlow and crew are highly appreciated," wrote one survivor.

MEIGS'S MISSION

In retaliation for the burning of Ridgefield, Connecticut, by the British during the Revolutionary War, the Americans planned revenge. They called upon Lieutenant Colonel Meigs. With a crew of 243 men, Meigs set off from New Haven

for Sag Harbor, where provisions were being stored by the British. They left on May 21, 1777, in thirteen whale boats. They arrived at Guilford, Connecticut, but had to wait until May 23 due to rough seas. With 127 men, they left at 1:00 p.m. and crossed the sound to Southold, arriving at 6:00 p.m. They carried the boats overland to the bay between the north and south forks, crossed the bay by boat and then hid the boats in the woods with guards upon arriving. The remaining men marched to the harbor and arrived at Sag Harbor at 2:00 a.m. An armed British schooner with twelve guns fired upon them, but to no avail. They succeeded in destroying twelve brigs and sloops, 120 tons of hay, corn and oats, ten barrels of rum and a large amount of merchandise. They killed 6 of the enemy and took 90 prisoners without suffering any losses. They returned to Guilford just twenty-five hours after leaving, their mission a complete success.

It Doesn't Walk Like a Duck

It was reported in August 1893 that Mrs. B. Wilson of Jamaica, Queens, was the owner of an oddity of nature—a four-legged duck. At the time her animal was discovered by the local press, the young rarity was just a mere duckling of ten weeks in age. It had three legs on one side, and one leg on the other. The two extra legs were positioned just in front of the normal leg. Waddling was perhaps considerably more awkward for this creature

than for any of its other fellow ducklings. Beyond that, nothing else about the bird was found to be strange or exceptional.

A MOUTHFUL

The original name of the eight-thousand-acre Shelter Island was Manhansack-aha-qushu-wamock, an Indian phrase meaning "an island sheltered by other islands."

LONG HOTEL IN LONG BEACH

In the 1890s, the Long Beach Hotel was quite popular among guests from the city who wanted to enjoy the sand and the sea. It was one of the largest hotels in the country, at 1,000 feet long and 160 feet wide, with six hundred rooms. The dining hall was said to have had a capacity of five thousand people.

RUM BAD, TOBACCO OKAY

The oldest veteran employee of the Long Island Rail Road in 1927 was Thomas Gallagher, age ninety-nine. He had retired at the age of eighty-one. When asked the secret of his longevity, he warned to keep away from rum, though he did admit to having chewed tobacco since he was fourteen years old.

AGE 110

Margaret Turpey of Flushing was still living in 1879, at the age of nearly 110. She had been born in Ireland in 1769, and arrived in the United States at the age of 85. By 1879, four of her five children had died, and she had been widowed for 46 years, but was reported to be in good health.

Too Much Coffee?

Sixty-year-old farmer Jacob Bedell of Baldwin/Freeport spent most of January and February 1879 wide awake. It seems Mr. Bedell did not sleep at all during an eight-week period that winter. Not even a wink. Further, he didn't even feel like sleeping. He claimed to have felt fine and suffered no ill effects during his bout with perpetual wakefulness. Apparently, he was right about that, for he outlived his wife, who died at the age of seventy-three in 1893; he lived to the age of eighty-five in 1903.

Riverhead Revenge

During the War of 1812, the British burned several ships that were based out of the town of Riverhead. Several other ships they captured and held for exorbitant ransom. The people of Riverhead were furious and determined to take revenge upon the British as soon as possible. During the spring of 1814, they finally had an opportunity to do so. On May 31, at ten in the morning, two large British barges, each with thirty armed men, were spotted heading for the shore of Long Island's North Fork near Riverhead. The cocky British kept advancing, heading toward the American sloop *Nancy* docked at the beach. They fired their cannons and a volley of musket fire and then gave three cheers that could

be heard from the shore. What the British did not realize was that about thirty American militia men lay in waiting for their arrival. As they were about to board the *Nancy*, no doubt to set her ablaze, the Americans fired their muskets at both barges. The surprised British made a hasty retreat, but not before suffering many casualties.

Seating Preferences

In August 1703, the trustees of the town of Brookhaven were up in arms about disorder in their church. "Whereas there hath been several rude actions of late happened in our church by reason of the people not being seated…it is ordered that the inhabitants be seated after the manner and form following." The meeting minutes laid out the monthly subscription prices to be paid for the best pews in the church; pews toward the back were free. The money paid went toward the salary of the minister, Reverend George Phillips. Pews 2 through 6 varied in cost from twenty shillings to nine shillings. Pew number 7 was for young men, 8 was for boys and pew number 9 was for ministers' wives and widows and for those women whose husbands were sitting in the forty-shilling seats. Maids who paid two shillings could sit in the alley fronting the pews. Other free seats were as follows: pew 13 was for maids, pew 14 was for girls and pew 15 was free for anyone to be seated. The best seats in the church, at a table toward the front, were to be given for forty shillings

a month. No women were allowed to sit there, except for the wife of Colonel William Smith, one of the founders of Brookhaven.

Connecticut, the Enemy

Long ago, Connecticut and New York were at odds over who controlled Long Island. Connecticut's colonial charter said that the "islands adjacent" would be part of Connecticut. Connecticut's claim on Long Island did not cause any misgivings for the residents of at least one Long Island town. In 1674, the inhabitants of Southold said, "We doe unanimously declare and owne that we are at this present time under the government of his Majesty's colony of Connecticut, and are desirous so to continue." These citizens refused to submit to the authority of New York and apply for a patent for their lands. This so outraged New York's newly arrived Governor Edmund Andross that he threatened to disenfranchise the citizens of Southold and treat them as enemies. In December 1674, Sheriff Silvester Salisbury was sent to Southold. Upon his arrival there, he called the inhabitants together and read the following note: "Gentlemen—Know yee, that I am empowered by ye Honoured Governor of New-York, to receive the return of this place into the collony of New Yorke...I do receive and accept of ye return and surrender of this place from under ye collony of Connecticut." In fact, so far did Andross's

anger over this topic go that he sent Salisbury to England in 1675 with a petition to King James for the annexation of Connecticut to New York. The citizens of Southold relented and received a patent for their land in 1676.

A Plum Deal

Plum Island, also known as Plumb Island and Isle of Patmos, was purchased by Samuel Wyllys of Hartford, Connecticut, from the Corchaug tribe of Indians in 1667. The price was one barrel of biscuit, one hundred muxes (iron drills) and a few fishhooks.

Well Preserved

Mrs. Elizabeth Jervis of Amityville celebrated her one hundredth birthday in July 1894. Forty of her eighty-nine living descendants (including seven children, nineteen grandchildren, sixty great-grandchildren and three great-great-grandchildren) attended a party in her honor. According to an article of the time, she was still very active and could read without glasses. She even retained the "luxuriant" hair of her youth and was remarked to be a "wonderfully well preserved woman." Mrs. Jervis died six months later, in January 1895, having lived in the same house for seventy-five years.

The Farmer Poet Strikes Again

During the late nineteenth century, a man from Little Neck was known as "The Long Island Farmer Poet." Bloodgood Haviland Cutter (1817–1906) wrote poetry on whatever subject tickled his fancy, some of which was published in the *Long Island News*. Topics included a beautiful quilt he had seen, the celebration of Columbus's arrival in the New World and a Sunday school cornerstone laying. The editor of the *Long Island News* praised the farmer poet's "sensitive writings" and exclaimed that he was in "mute rapture" upon reading them. Cutter was actually a wealthy man and also a friend of Mark Twain's, and was in on a practical joke played on him one April Fool's Day, when 150 of Twain's literary friends and admirers sent him notes asking for his autograph. Twain referred to Bloodgood H. Cutter as the "Poet Lariat" in his book *Innocents Abroad*, published in 1869. The colorful character could often be seen on the streets of Little Neck with a Bible in hand. In 1886, he paid to have a five-hundred-page book of his poems published.

One day the farmer poet was on his way to market in New York City with a wagonload of produce when he broke down. Just as he stepped off his wagon to examine the situation, a wagonload of neighbors heading home approached. One of the men said to the others, "There's our rhyming neighbor Cutter, broke down, bet you all the dinners all round at Tony's that when we stop he will tell

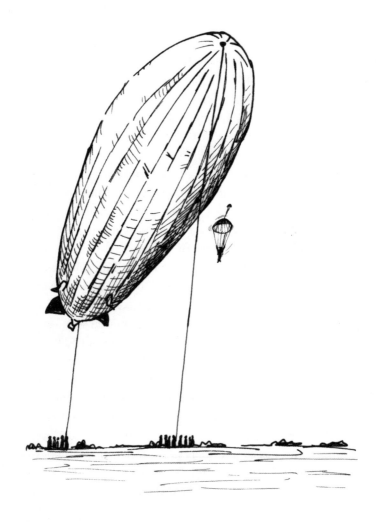

us his trouble in good rhythm." One of the man's friends happily took the bet. So they pulled up to Cutter, and sure enough, he spoke in verse:

> *Glad to see your smiling faces;*
> *I've broke down and want relief;*
> *Come and help me mend my traces,*
> *Or my trip will come to grief.*
> *I've a load of pink-eyes beauties*
> *Rare potatoes—sure to sell—*
> *Don't forget your Christian duties*
> *Pious work, you know, pays well.*

Hearty peals of laughter broke out among the men. They helped Bloodgood out of his jam and looked forward to a free dinner.

FULL OF HOT AIR?

The R-34, a British dirigible, left Scotland on July 2, 1919, and landed in Mineola on July 6, after a nonstop flight of 3,200 miles. It was the first crossing of the Atlantic Ocean by a lighter-than-air machine. The total flight time was 108 hours and 12 minutes, an hour faster than the fastest crossing of the ocean liner *Mauretania*. People came from all directions to Roosevelt Field as the giant airship was spotted. Before landing, one crew member, Major John

Edward Pritchard, parachuted out of the airship from 1,500 feet up to make landing arrangements. He signaled to his ship once the arrangements were made. The ship descended more and then dropped a long rope. Soldiers on the airfield grabbed the rope and pulled, bringing the R-34 safely to the ground.

MARRIAGE SUITED HER

Kate Mott Nugent, born in Bay Shore, appeared in court in Riverhead in June 1891 on a charge of bigamy. This was not the only interesting fact of her case. It seems she had married first at the tender age of twelve to a man named George Gregory. Then she took a second husband, Frank Fox, at the age of thirteen and while still married to Mr. Gregory. She married a third time before she even turned fourteen, to Lincoln Nugent, who eventually abandoned her. During these early teen years, she also had a child. It was only with her marriage to a fourth husband, Oliver Potty of Port Jefferson, that she got into legal trouble and was charged with bigamy. By all accounts, the accused bigamist was very attractive. She had lived through a difficult childhood, having no mother to raise her. Mrs. Gregory Fox Nugent Potty arrived in court wearing a lovely pink silk robe. Two of her estranged husbands were in court for the trial, but they were drunk. In fact, one of them was disorderly and had to be hauled away by the sheriff. Her third husband denied that he

had ever actually been married to her. There was no other testimony given that was conclusive about any of her first three marriages.

HUNGRY CROWD

At the Brooklyn and Long Island Fair of 1864, huge crowds turned out to see the exhibits. The food eaten there in a single day included 100 turkeys and chickens; 100 grouse, quail and ducks; 500 pounds of beef, lamb and venison; 20 hams; 18,000 oysters; 35 pounds of fish; 60 quarts of jelly; 800 quarts of ice cream; 250 gallons of coffee and tea; 400 loaves of bread; and 200 heads of celery.

AT LEAST HE GOT A HIT

Leo Fishel of Babylon was a pitcher for the New York Giants baseball team in the closing days of the nineteenth century. He attended Columbia University and pitched for their baseball team. His first Major League game was on May 3, 1899. He pitched a complete nine-inning game, but lost. In his Major League debut he walked six, struck out six, hit two batters and had one wild pitch. He allowed seven runs, six of them earned, and lost the game, never to play in the Majors again. On the bright side, as a batter, he did get one hit in four at-bats.

HE SWALLOWED *WHAT*?

Leo Fishel's older brother Harry was also known as an excellent baseball player. It was reported in July 1894 that Harry was taken to a hospital in New York after accidentally inhaling part of a broomstick he was keeping in his mouth. The piece of wood became painfully stuck in his windpipe. One doctor told him to wait and it would eventually pass into his stomach. Harry tried to remove the wood himself with no luck, and was finally brought to the hospital, where he was operated upon. After some tense moments, doctors felt he would recover.

OLD MAN TITUS

Old Jacob Titus of Wheatley died on August 28, 1792, at the age of ninety. He lived to see the fifth generation of his descendants, which were said to number over 250.

NOW THAT'S AN OX

In the year 1800, Mr. George Hewlett of Hempstead was very proud of the freakishly large ox he had raised. The beast wound up at Mrs. Delouf's Flymarket, where there was a one-shilling admission price for the curious. The huge

creature was reportedly 19 hands high (6 $\frac{1}{3}$ feet), 17 $\frac{1}{2}$ feet long and 9 feet in girth. A newspaper of the time encouraged people to see the ox, saying, "Not to view him as he now stands argues the want of that curiosity which tends to enlarge the mind."

Big Duck Walks

Suffolk County's famous "Big Duck" was built in 1931 by a farmer who used it as a shop from which to sell ducks and eggs. The twenty-foot-high quacker-shaped building was no sitting duck, however. Originally built in Riverhead, it was moved after a few years to Flanders (a few miles to the southeast). During the 1980s it was moved again, farther east to Hampton Bays, but by late 2007 the duck had returned to Flanders.

Speed Limit

The automobile, a brand new invention at the turn of the twentieth century, had many Long Island residents up in arms. They worried about these new contraptions speeding down their roads and byways at breakneck speeds of twenty-five miles per hour. State Senator William Willets Cocks of Westbury decided to do something about this. He introduced a bill into the New York State Legislature that regulated the speed of automobiles. The bill was passed and signed

into law by Governor Odell in April 1902. Cars were not to be run on country highways faster than twenty miles per hour or in villages or cities faster than eight miles per hour. The first violation was punishable by a fine of up to fifty dollars, and each additional offense could be punishable by imprisonment or fine, or both.

THE HAUNTED HOUSE OF MASSAPEQUA

Near Massapequa Lake (in an area that used to be known as Fort Neck), there stood for many years a venerable home known as the "Old Brick House." In 1692, a man named Major Thomas Jones came to America from Ireland and settled at Fort Neck. He built the brick house in about 1695 and lived there for nearly twenty years. Known as Pirate Jones, the "pirate" was in fact a privateer who had been authorized to seize enemy ships, but the line between pirate and privateer was a fuzzy one. In any event, Jones's pirating days were supposedly over once he moved to Long Island. In 1704 he was named the high sheriff of Queens County.

Still, as the years passed, many legends and tales have emerged about Pirate Jones. It was said that he buried some of his old pirate treasure nearby. As the story goes, one day he came upon a black boy and asked if he would guard the treasure. When the boy said he would indeed watch the treasure, the ruthless pirate killed the boy and threw his body upon the chest as he buried it in swampy ground. Local residents told of

hearing the cries of the boy in the swamp where the treasure was supposed to have been laid (this subsided once the swamp was flooded when a dam was built nearby).

The pirate eventually grew old and sick, and legend has it that as the aged Major Jones was taking his last few breaths in December 1713, a big black bird flew into his room and perched upon his pillow. The bird remained in the room until the old pirate passed away and then flew out of the house through an oval window. Thomas Jones was buried among Indian ruins on his property. His gravestone featured the words that he himself had dictated: "From distant lands to this wild waste he came, this spot he chose, and here he fixed his name; long may his sons this peaceful spot enjoy, and no ill fate their offspring ere annoy." Though his gravestone wished his descendants well, strange goings-on occurred after his death. To start, after his death, the oval window could not be closed properly. Every night, the pirate's ghost would enter the window and take a walk. As legend of this haunted house spread, people came from all around to see for themselves the mysterious oval window. The old man's sons and grandsons tried desperately to close the troublesome window—they locked it, boarded it up and bricked it over every which way they could, but as soon as night came "their work would be destroyed, and strange sights would be seen and awful voices heard." They finally gave up and moved out of the house for good. One of Jones's sons built another house on a different part of the property, but would have nothing to do with the haunted brick house.

The old brick place was finally torn down in 1837, after more than one hundred years without occupants, and with it disappeared the pirate's ghost. The physical remains of Major Thomas Jones also had some adventures. Rumors had circulated that Jones had been buried with some valuables, and vandals dug up his grave, leaving the bones scattered. Someone took the upper half of Jones's skull, thinking it to be of some value. The missing bone was not reunited with the rest of the remains until 1893. The family discovered that someone had scrawled on the grave a little rhyme that went: "Beneath these stones repose the bones of Pirate Jones. This briny well contains the shell, the rest's in hell."

PUMPKINS A PLENTY

In early November 1826, it was reported that John Hewlett of Eastwoods had a huge pumpkin vine growing on his property. One branch of the monstrous vine was 35 feet long and another 45 feet long, while the other six were 170 feet long, for a total of 250 feet of vines on a single plant. The one vine yielded twenty-four fine large pumpkins, weighing a total of four hundred pounds.

A LONG RIDE

The first single-day bicycle ride of one hundred miles on Long Island took place during the summer of 1883, not long after the modern bicycle was introduced. It was reported that an attorney named James Allen set off from his home in Hempstead at 4:35 in the morning one day, and rode through South Oyster Bay, Amityville and Babylon en route to Islip. He arrived in Islip after 2¾ hours, and then proceeded to Patchogue, where he stopped for breakfast from 9:20 to 10:30 a.m. The next thirty-eight miles included eighteen miles of sandy travels through scrub oak and pines, at the peak of the summer day's heat, on the way to Quogue and then Riverhead. Allen had a hard time keeping his balance on this leg of the trip. At Riverhead, he rested for an hour, then at 5:15 p.m. proceeded to ride the final twenty-two miles to Greenport, arriving at 7:05 p.m., 14½ hours after starting off. Mr. Allen originally did not want his name printed in the account of his ride, for fear it would seem like he was boasting.

TURTLE IN THE HALF SHELL?

In June 1816, it was advertised that a fine, large green turtle would be dressed, cooked and served on Saturday and Sunday at two in the afternoon at Tyler's Boarding House in Far Rockaway.

Ghost of the Grain Sheaves

In December 1844, an old farmer named Jacob Smith had an unwelcome visitor on his property along Merrick Road. It seemed that during the night, his grain stacks were being taken apart and the sheaves scattered around his yard haphazardly. Old Smith was not happy that his hard work was being undone on a regular basis. Neighbors said it was the work of ghosts who had been rumored to visit the farmer's house. Smith suspected otherwise and got very angry at even the mere mention of the word "ghost." So one night, the brave farmer loaded a birding gun and staked out the yard. Nothing happened that night, but a couple of evenings later, around about ten o'clock, Smith saw a shadowy figure enter his yard and make for the grain stacks. The farmer called out, "Lay down those oats!" There was no reply. Then he said, "Lay them down or I'll shoot!" The ghost said, "Shoot and be damned!" but at the same time held a sheaf in front of his face. Unafraid, Smith fired the gun, and the "ghost" was injured. From that day forward, one of Smith's neighbors had a scar on his left cheek from his mischievous shenanigans. The grain was left untouched after that incident.

A Radish to Relish

During the summer of 1816, a lucky farmer in Newtown, Queens, grew a gigantic radish. This vegetable was five feet, ten inches in length, including the top. The body of the radish was two feet, nine inches in length, and its circumference was two feet, three inches. The oversized radish weighed in at a hefty twenty-one pounds.

Man Versus Bear Versus Wolf

In July 1894, an animal trainer named Professor Crocket was working a show in Rockaway Beach when an unfortunate incident occurred. In the middle of a performance, the bear he was working with sunk his teeth right into Crocket's arm, causing a bleeding wound. The professor yelled for help. Unfortunately, no one was brave enough to offer assistance; instead, much of the audience fled. However, a pet wolf of the professor's came to the rescue and pounced upon the wild bear. The professor escaped. He was expected to recover, but no further information was available on the brave wolf or the offending bear.

GUNS IN CHURCH—YES, DOGS FOR INDIANS—NO

Early colonial laws of Long Island were rather severe at times. In the town of Easthampton, some of the laws were as follows. In 1650, no more than half a pint of liquor could be drunk at a time among four men, and it was also forbidden to sell any dog to an Indian. Also in 1650, it was ordered that any man could fire a gun to kill wolves, as long as it was no closer than half a mile from the town. In 1653, it was ordered that one half of the men should carry guns to their Sunday worship "with four sufficient charges of powder and shot." In 1656, it was ordered that whoever bore false witness against another person would have done to them what they falsely accused the other person of doing, "whatever it be, even unto the taking away of life, limb, or member." Anyone who slandered another townsman would have to pay a fine of five pounds.

THE PROOF IS IN THE WOLF'S HEAD

In February 1663, the town of Jamaica voted that whoever killed a wolf and nailed its head to a tree as proof would receive seven bushels of Indian corn. There was no word on how much was paid to the person who removed the smelly mess of a decomposing head from the tree after a few days.

OLD SNAKE EYES

It was reported in Freeport in the winter of 1879 that one of Jacob Smith's horses suddenly became blind in its right eye. Many observers noticed a peculiar phenomenon upon closer examination, something "resembling a snake" inside its eye, three inches in length and needle thick. It looked similar to an eel swimming in water. Three days later, the squirmy little creature was gone, but the horse was still blind.

THE WITCH OF OYSTER BAY?

In 1660, a poor Oyster Bay woman named Mary Wright was accused of being a witch. Everyone in town was in agreement that this was a serious charge. The only problem was that the townspeople had never dealt with such a case before. Unlike their New England counterparts, they were unfamiliar with the means and methods of investigating and judging suspected witches. So they had her transported to the general court of Massachusetts colony, where she was thoroughly questioned. In the end, it could not be proved that she was a witch, and she was found innocent. However, she was found guilty of being a Quaker, which was also considered to be a serious crime at that time.

SAID NO! TO HIGHER TAXES

Deputy Constable Richard Combes came knocking on the door of Daniel Bull's house in Jamaica in September 1718 to collect a tax. Bull answered the door, and said no way, he would not give one cent. Combes insisted that he had to pay. The angry Bull grabbed an axe and swung it over Combes's head. "I'll split your brains," he told the constable if he tried to take any money. Another man, named Jacamiah Denton, came to the window. The constable commanded him to help in the name of the king. Denton laughed heartily and said no. The poor constable then left and rounded up a posse of sixteen people, but when he got back, he found Bull and six other men at the door, stripped to their shirtwaists, holding huge clubs. They lifted their clubs, poised to swing, and taunted Combes. Bull stepped forward and told Combes if he took one more step he would bash his brains out. Seeing there were at least twenty men on Bull's side, the constable left and tried to recruit more men to help him, but met with no success. In fact, George McNish, a Presbyterian minister who happened to be nearby, told the various men Combes approached not to obey. When the matter came before a judge a couple of months later, the rioters apologized and were let off with a fine of twenty-six pounds, ten shillings.

IS THAT ANY WAY TO TREAT A KING?

When the Declaration of Independence was read for the first time in Huntington in July 1776, the assembled crowd applauded and shouted loudly. They ripped the letters "George III" from a flag and proceeded to quickly make an effigy of the king. It had a blackened face and a wooden crown with feathers in it. Its body was wrapped in the Union Jack flag, lined with gunpowder, hung on a gallows, exploded and allowed to burn to charred ashes. That evening there was a large celebration in town, during which thirteen patriotic toasts were drunk.

JOHN BULL'S TALK

One of the last old-time Indian chiefs on Long Island was a man called King Ben of Whale's Neck. He used to tell stories of the early settlers' interaction with the natives. One was the story of John Bull. The early English settlers told several Indians that "John Bull" wanted to have a talk with them. The only catch was that John Bull was not a person—it was a large cannon. ("John Bull" was a British version of the later American concept of Uncle Sam.) On the appointed day, the Indians were lined up single file in front of the mouth of the cannon, which was then shot off. According to King Ben, the murder of these Indians angered the Great Spirit so that during the time of year when the incident occurred, nothing

would grow at that place, where the soil was still stained red from the blood of the murdered.

WHEN RACCOONS ATTACK

In September 1897, a Brooklyn man and his wife were attacked by wild animals upon their return home one evening from their country house. As they stood on the steps to their home, two dark-colored, dog-sized animals appeared.

The attacking creatures were persistent. Though Mr. Smith managed to fight off one of them, the other one continued to attack and bit the tip off Mr. Smith's finger. Neighbors called the police upon hearing all the commotion. Luckily, a policeman arrived just in time to shoot the wild raccoon, as it was about to bite into the man's throat. He fired his gun and killed the feral animal, which was then measured to be two and a half feet in length.

WORST DROUGHT

It is said that in 1762, between May and November there was not a single drop of rain fallen on Long Island. It was the worst drought in memory. The local farmers were said to have suffered immensely, and the next year they formed the Agricultural Society of Long Island.

OLD MR. COOPER

In October 1894, old Mr. Cooper died. Mr. Cooper was, appropriately enough, a cooper who lived in Sag Harbor. He had fallen earlier in 1894 and hit his head, an injury from which he'd never recovered. However, it was reported that some years earlier, he had swallowed his false teeth and experienced no serious side effects.

BYRAM, THE SELF-TAUGHT INVENTOR

During the 1830s, there lived a self-taught mechanic, inventor and astronomer named Ephraim Byram. But Byram was not a world traveler. The man was so busy creating contraptions that he barely left his shop in Southampton. In fact, he hardly ever left the village, and if he did he rarely ventured more than a mile from home. Though he had no education, no wealth, no real family to speak of and was quite frail of body, Byram was a tireless genius. He built clocks, organs and telescopes, among other mechanical gadgets. He built numerous clocks for church towers, including the ones in Sag Harbor's Methodist and Presbyterian churches. At one point, Byram built a planetarium that was said to exhibit perfectly the relative positions of the planets in the solar system, and even demonstrate their movement.

IN THE DAYS BEFORE SPELL CHECK

In the New York General Assembly in September 1701, Thomas Willet, John Tallman and John Willet were expelled and declared guilty of contempt in part for sending in a paper to the house that was "in barbarous English, and shewing their ignorance and unacquaintantedness with the English language." The offensive note they submitted read as follows:

On the 20th day of Ougost last, the house, consisting of 2 persons, whearof the Speeker was one, Tenn of the number did in the House chalings the Speeker to be unquallified, for his being an aliane, and afterwards did repetit the same to the Govner, which they have all so giv in under theare hands; upon which heed the House being equally divided, could give noe decision. Till you giv us fader satisfacktion, and the Speeker clere him self from being an aliane, we cannot acte with you, to sit and spend ower Tyme, and the country's money, to mak actes that will be voyd in themselves.

CAPTAIN KID

Most nineteenth-century Long Island boys passed their teenage years in school or working menial labor, perhaps as an apprentice. Not Samuel J. Woodhull of Woodbury. At the age of thirteen he went to sea as a cabin boy. He must have liked it, because he spent the next eight years of his life on ships, working virtually every job a ship could offer. In 1870, he helped quell a mutiny onboard the brig *Moses Rogers* at Rio de Janeiro, Brazil. The ship's owners were so pleased with his actions that upon his return to the United States, they named him captain of the *Moses Rogers*. Samuel Woodhull had just turned twenty-one, making him perhaps the youngest ship's captain ever to hail from Long Island. The young man, being of sound financial mind, did not spend all his money on wine and women in every port of

call. Instead, he saved up his earnings and invested in a stake in the *Moses Rogers*.

THE OLD TAX MAN

At the age of ninety-seven, Stephen J. Wilson of Babylon was the oldest officeholder in the state of New York. Until his death in February 1901, Wilson was collector of taxes for School District Number 1 (a post he had filled for twenty-three years) as well as collector of village taxes. During his long career, he had also served as sheriff, deputy sheriff, constable and trustee.

ICE SCOOTER

In July 1907, Nathaniel Roe of Patchogue was granted a patent for his new invention, an ice scooter. The fourteen-foot-long craft was designed for fun. According to the patent application, it "affords a lively recreation to pleasure seekers and in the event of it plunging into the water in soft ice…it would float the same as a boat." The scooter prototype featured the same engine used in airplanes of the time. In a test in January 1907, the scooter reached seventy-five miles per hour, and Mr. Roe was certain he would be able to get the speed up to one hundred miles per hour. At the time, this invention never quite caught on, but it sounds like it would be quite popular these days.

Escape with Sheep and Ducks

During the early days of the American Revolution, in August 1776, American Captain Lambert Suydam was ordered to go with his company of men to Rockaway. Passing the home of a man named Van Brockle, he discovered a number of half-naked Loyalist men fleeing out the door. Suydam ordered his men to capture the Tories. They captured three fairly easily, and found another two men hiding under some bushes in the woods. Captain Suydam next examined the beach, and found a ready escape boat with four oars and a paddle. Inside the boat were three patient sheep, four ducks and a large bottle of water.

Fifty Barrels of Beef

In 1680, the town of Southampton decided to pay their minister, a man named Joseph Taylor. He was to have four acres of pastureland for his use, as well as one hundred acres of woods. His yearly salary was to be £100, payable in a combination of the following items: winter wheat, summer wheat, Indian corn, tallow, green animal hides, dry hides, beef, pork, whalebone and oil. At seventeenth-century Long Island prices, that salary was enough to give Minister Taylor five hundred bushels of summer wheat, eight hundred

bushels of corn, fifty barrels of beef or 2,667 pounds of whalebone.

Does It Keep Witches Away Too?

In 1657, one Mrs. John Garlicke was brought before the Easthampton town court on suspicion of practicing witchcraft and causing a child to die. Several witnesses were called to testify. The judges conferred, and feeling unable to make a judgment themselves, decided to send poor Mrs. Garlicke to Connecticut for a further trial. One of the witnesses, mother of the deceased child, happened to be in the employ of Lyon Gardiner, who suspected that the witness was lying. It seems that this witness had taken an Indian child to nurse, and because of the money she was being paid for this service, fed the child at the expense of her own child's health. Gardiner suspected that she accused Mrs. Garlicke to divert suspicion from herself. Though "Goody Garlicke" had been accused of witchcraft, with a name like that at least she could not have been suspected of being a vampire.

The Only Good Wolf Is a Dead One

Wolves were once abundant on Long Island. It was said that Indians used to keep dogs, which in fact were young wolves they had raised to be tame. The early colonists considered

wolves a nuisance to their livestock. In 1685, the government of Suffolk County spent forty-three pounds, thirteen shillings to kill wolves, including sixteen in Easthampton, three in Southampton, one in Southold, two in Brookhaven, six in Smithtown and fifteen in Huntington.

Throw in Another Coat and Some Hoes, and You've Got a Deal

During the mid-seventeenth century, the English made some of their first deals with the local Indians to buy land. Part of Huntington was purchased from the Indians for six coats, six bottles, six hatchets, six shovels, ten knives, six fathom of wampum, thirty muxes (iron drills) and thirty needles. About thirty thousand acres in Easthampton were bought for twenty coats, twenty-four mirrors, twenty-four hoes, twenty-four knives and one hundred muxes. Around twenty thousand acres in Oyster Bay were purchased for six coats, six kettles, six fathom of wampum, six hoes, six hatchets, three pairs of stockings, thirty awl blades, twenty knives and three shirts.

35+14+90=Confusion

In April 1888, a thirty-five-year-old Amityville woman named Annie Smith went before a ninety-year-old minister

named Frederic Sizer, intending to marry a fourteen-year-old boy named Birtzel Dean. The first preacher they had tried would not perform the marriage without the consent of the boy's parents. Old Reverend Sizer said the boy claimed he was twenty years old, while the bride said he told her he was sixteen years old. In any case, the couple never actually lived together, and Dean later claimed he did not understand what was going on when he agreed to marry her. Mrs. Dean had her husband arrested for abandonment and nonsupport, but the judge dismissed the case on the grounds that Dean, being an "infant" at the time of his marriage, could not legally make a contract. The boy's father next took the case to court to get the marriage annulled.

WHIRLWIND ROMANCE

A wealthy old Sayville man named Thomas Hawkins was perfectly happy as a bachelor. Long ago in the prime of his youth, he had been considered desirable as a prospective husband, but was more recently known as kindly old "Uncle Thomas." One day in 1893, when he was seventy-three years old, he answered his door and found a tired young woman asking for some water to drink. She was Catherine Kavanagh, the twenty-nine-year-old servant of a neighbor. He obliged her and was immediately smitten. Their courtship was quite rapid. One night at ten o'clock, about three weeks after the woman had first stopped by for water, an excited Mr.

Hawkins woke the local minister and told him to come out so he could perform a wedding ceremony. A small party was thrown following the ceremony.

HAUNTED POLICE STATION

In September 1902, the Flushing police moved into a new station house. The "new" house was actually an old building that they thought would be more spacious than their previous location. Just a few days later, a policeman named Hanniman spent a frightful night in the station house. He heard strange noises all night long, and the next morning asked to be transferred, saying he would not set foot in that place again. When Hanniman's colleagues investigated, they found a leaky gutter that was dripping, but even after they silenced it, the odd noises continued. Others claimed that the noises sounded like the moan of a woman and that a white-robed specter had been spotted in the hallways at night. Legend had it that a young woman had been found dead in the house years before, possibly the victim of murder.

FAT WOMAN VERSUS SKELETON MAN

During the eighteenth and nineteenth centuries, a greatly anticipated annual event called the "sheep parting" took place every fall on the Hempstead Plains just southwest

of Westbury. Farmers came to collect their sheep, which had been grazing on the plains during the summer. This became a social gathering and developed almost a carnival-like atmosphere. For example, at the 1839 event, there were tumblers, clowns and harlequins. There was also dancing, racing and wrestling. Food offerings included cake, gingerbread, beer, oysters, watermelons and roasted corn. The featured entertainment was a "fat woman" who weighed four hundred pounds and was kept in a tent, and a "skeleton man" who weighed sixty pounds and was kept in a covered wagon. Both could be viewed for the cheap price of one shilling.

POSSUM SUPPER

In January 1901, Supervisor Brush of the town of Huntington received a desperate letter from the pastor of a church in Gloversville, in upstate New York. It seems the church faithful had arranged a possum supper, but no possum could be found. The supervisor stayed out late and rounded up eleven fine specimens, and shipped them straight off to Gloversville, much to the delight of both the pastor and the local farmers of Huntington.

Monkey Gone Wild

An escaped monkey may not sound as dangerous as an escaped lion, but to a Commack neighborhood, a seventy-five-pound creature on the loose was quite a menace. After it escaped from its owner, it became violent. In August and September 1936, the animal attacked numerous pets in the area. That is, until Martha Schmidt of the Rainbow Nursery shot its head off with a shotgun.

The Witches of Brookhaven

In 1665, Brookhaven residents Ralph Hall and his wife were accused of witchcraft. The charge against Mr. Hall said,

> *By some detestable and wicked Arts, commonly called Witchcraft and Sorcery, did (as is suspected) maliciously and feloniously, practice and Exercise at the said town of Seatalcott...on Long Island aforesaid, on the person of George Wood, late of the same place, by wch wicked and detestable Arts, the said George Wood (as is suspected) most dangerously and mortally sickened and languished, And not long after by the aforesaid wicked and detestable Arts, the said George Wood (as is likewise suspected) dyed. Moreover, the Constable and overseers of the said Towne of Seatalcott...do further Present for our Sovereign Lord the King, That some while after the*

death of the aforesaid George Wood, the said Ralph Hall did (as is suspected) divers times by the like wicked and detestable Arts, commonly called Witchcraft and Sorcery…on the Person of an Infant childe of Ann Rogers, widdow of the aforesaid George Wood deceased, by wh wicked and detestable Arts, the said Infant Childe (as is suspected) most dangerously and mortally sickned and languished, and not long after by the said Wicked and detestable Arts (as is likewise suspected) dyed, And so the said Constable and Overseers do Pressent, That the said George Wood, and the sd Infante Childe by the wayes and meanes aforesaid, most wickedly maliciously and feloniously were (as is suspected) murdered by the said Ralph Hall.

The same indictment was read against Mary Hall, and depositions were read but no witnesses appeared in person before the court. Ralph and Mary Hall pleaded not guilty, and their case was referred to the jury. They found that "wee having seriously considered the Case committed to our Charge, against the Prisonrs at the Barr, and having well weighed the Evidence, wee finde that there are some suspitions by the Evidence, of what the woman is Charged with, but nothing considerable of value to take away her life. But in reference to the man wee finde nothing considerable to charge him with." The suspects were then acquitted and released.

BED OF OYSTERS

In September 1859, a huge oyster bed was accidentally discovered in Long Island Sound. Five men from Connecticut were pulling up a dredge that had served as an anchor when they noticed some oysters in it. They explored further and found a rich supply of oysters over what they estimated to be a square mile of territory. Looking to make some money off their find before it got out to the general public, they approached some City Island oystermen and told them for $500 they would reveal the location of a tremendous oyster bed. The oystermen thought it over and agreed. When they got to the site and it seemed to be just as bountiful as the finders described it, they handed over the money. That first day, the oystermen from City

Island took in about seven hundred bushels of oysters. But news of their secret spread rapidly. Soon, two hundred boats could be seen chaotically plying the lucky waters, sailing in every which way. In a day, they pulled more than five thousand bushels of oysters from the sound floor. A report of the time decried that men would be driven by greed to fish for oysters on Sunday and "desecrate the Sabbath." Some estimated the oyster bed to be worth millions of dollars.

THE BOTTOMLESS LAKE

Lake Success was for some time imagined to be a bottomless lake. Located in Lakeville, near Great Neck, the lake had a mysterious history over the years. Many swimmers drowned in the lake, but the bodies were not always recovered. These victims, some of them quite experienced swimmers, would sometimes throw their hands into the air suddenly and then disappear into the water. One explanation was that wildly varying lake temperatures caused swimmers to have cramps and drown. Another theory was that some sort of giant undersea creature dwelled in the lake. Curious people often tried to measure the depth of the lake, but their attempts were in vain. Once a horse pulled a wagon into the lake and neither was found again, despite a search. In 1927, police looking for a drowning victim spent 250 feet of rope and still did not hit the lake bottom. In fact, it was said that once 100 fathoms (600 feet) of rope were dropped into the lake, and the

end of the rope still did not touch the bottom. The millionaire William K. Vanderbilt Jr. once owned the eerie lake.

THE WRECK OF THE *SYLPH*

In January 1815, one of the worst shipwrecks in Long Island history occurred. It was toward the end of the War of 1812, and the three-year-old, twenty-one-gun British sloop *Sylph* was passing near the south coast of Long Island on its way to New London, Connecticut, when she became mired in a thick fog. The ship struck a bar opposite Shinnecock Point. When the wreck was discovered, men from Southampton quickly gathered to attempt a rescue. There was a snowstorm raging and the ship was breaking up in the high surf. The rescuers managed to launch a small boat and were able to save six lives. These survivors had been through an ordeal, but they soon became prisoners of war. More than one hundred others were not so lucky and died in the cold waters, despite attempts to save them. A memorial plaque was created in St. Andrew's Church at Southampton, made in part from pieces of red cedar salvaged from the shipwreck.

SAW GHOST, BECAME GHOST

The Oertel family of Glen Cove got quite a shock in the late nineteenth century when they discovered that the ghost of

an old seaman named Captain Russell, who had lived and died there, haunted their home. He would usually come in through the chimney dressed in old-time sea captain's garb. After some frightening but harmless haunting, the phantom was said to disappear from whence it came. That is, unless it felt like vanishing through a keyhole. In that case, it would shrink into a tiny fleck of light, fly through the keyhole and disappear. Mrs. Oertel was most affected by the spirit, which would appear at her bedside. Though it could be frightening and sometimes yanked on her nightgown, she became used to the old ghost. After the Oertels moved away, a man named William Eastment purchased the home. The Eastment family came to the same conclusion as the Oertels had years earlier: that a ghost inhabited the house. Only this time, it was said to be the spitting image of Mrs. Oertel herself, wearing a shawl and bonnet. The dearly departed Mrs. Oertel would shake her fist at Mrs. Eastment and then vanish.

DIG FOR WATER HERE

Legend has it that the Native Americans of central Long Island were at one point in dire need of water. It was said that they prayed to the Great Spirit for help. The Spirit told them that their leader should shoot an arrow and at the spot where it fell, they should dig for water. Sure enough, they found water there, upon a hilltop that became known as Manetta Hill (originally Manitou Hill). A well located there

in the late nineteenth century was said to be on the exact spot where the original discovery had occurred many hundreds of years before.

ANOTHER BOTTOMLESS LAKE

Lake Success was not the only Long Island lake that was supposed to be bottomless. Suffolk County's Lake Ronkonkoma was also deemed to be of vast and unmeasurable depth. It was alleged that objects dropped into the lake made their way through subterranean chambers into the Great South Bay and the Atlantic Ocean. It was also said that every seven years, a strange and powerful tide affected the lake. Eighteenth- and nineteenth-century settlers also heard stories about a ghostly Indian girl ("The Lady of the Lake") who haunted the lake and took a male victim every so often. According to the tales, the Lady would call her victims and lure them into the deeper waters, and then the unlucky boys would be found drowned some time later. In 1889, a pair of scientists named Fred Mather and Bashford Dean set out to measure the lake once and for all. As outsiders, they encountered skepticism and resentment among the locals. They found the average depth to be about fifteen feet, except for an especially deep area that they measured at sixty-five feet.

First Long Island Flight

The first airplane flight on Long Island took place July 17, 1909, when the aviation pioneer Glenn Hammond Curtiss came to Mineola with his plane. The previous month, he had made the first flight in New York City, but found the airfield there too small for his liking. At Mineola, on the Hempstead Plains, he found the ideal conditions for takeoff and landing. Curtiss was trying to win the coveted Cortlandt Field Bishop prize of $250, offered to the first four people to fly a distance of one kilometer. It took him only two and a half minutes to win the prize, but he kept going and wound up flying nineteen circuits for a total of nearly twenty-five miles, at an average speed of thirty-five miles per hour. A crowd of people had gathered to see the historic flight, many wondering if such a thing was even possible, having never seen an airplane before.

The Great Flood at Hempstead

The winter of 1838–39 was severe on Long Island. There were great amounts of snow that covered the Hempstead Plains, and the ground was frozen solid. In March of 1839, heavy rains flooded the plains. Floodwaters flowed down two brooks that ran through Hempstead village and flooded them. Snow and ice formed a barrier at the junction of the

two streams and the water flooded the village. Five feet of water were reported in the dry goods store of Mr. Weeks at Front and Main Streets. Five feet of water also flooded Burtis's shoe store and Crossman's hat store. The entire length of Front Street was under about four feet of water. The lumber in Snedeker's lumberyard washed away. Some of the homes, stables and shops near the streams were carried away in a torrent when the water broke through the snow blockade. Isaac Eldred's farmhouse, outside of town, was an astonishing sight, a lonesome little island in a vast lake of water on the Hempstead Plains. The damage was estimated to be in the thousands of dollars.

HEALTHY OLD SYC

One of the largest trees on Long Island was an American sycamore nicknamed "Old Syc." The tree was estimated to be 320 years old in 1952. Located on Wheatley-Brookville Road in Wheatley Hills, the tree was measured during an old tree survey in 1952 with a circumference of twenty-six feet and seven inches (nine feet in diameter). By 1972, it had grown to twenty-eight feet and two inches in circumference. Normally, trees are measured at a height of four feet six inches above the ground, but this tree had to be measured at only six inches above the ground because it had no trunk to speak of. There were a few interesting stories tied to the venerable old tree. One was that around 1830, the local butcher hung slaughtered

beef and hogs from its limbs while butchering them. Another was that in colonial times, a farm wife took one of the main shoots of the young tree to use as a rod to tie candlewicks for dipping into hot wax. This was one theory as to why the tree had no real trunk. Another was that fourteen feet of soil were filled around the tree when the surrounding woods were cut down long ago. Rumor also had it that some workmen, when filling a hole in the tree in the twentieth century, placed a beer can and soda bottle in the concrete fill.

FIRST MAIL CARRIER OF THE SOUTH FORK

Jerome Downs, said to be the first mail carrier on the south side of eastern Long Island, took mail from Sag Harbor to Brooklyn in a single mailbag on horseback. Mr. Downs was said to be alive and well in 1894, living in Bayport at the age of eighty-five.

THE HUCKLEBERRY FROLIC

The Washington Race Course (also known as New Market or Salisbury Plains) was located northwest of Hempstead Village. Besides races, it was also the site of the infamous "Huckleberry Frolic," a carnival-like festival held every October. At the 1846 Frolic, for example, there were horse races, foot races, women's races, sack races, tumblers, fire

eaters and wild animals from the Arabian desert and the Siberian mountains. The festival was reported by visitors to feature much profanity, obscenity and wickedness.

LONG ISLAND FOSSILS

In July 1858, the bones of a giant animal were uncovered in quicksand at Nostrand's Pond, about three miles southeast of Jamaica. Workers were digging a canal for water supply to Brooklyn when they came across the discovery. They soon determined that the bones of the whole animal were present, spanning over fifty feet in length. A guard was put there to protect the find. The bones were deemed to be from a giant marine creature or a mastodon. Some years before that, at Cedar Swamp in Merrick, a large animal's backbone had been found in the muck. It was at first thought to be a whale, but then a scholar examined it and said it was a four-legged herbivore. As workers continued to dig, more bones were found. The bones were removed and loaded into a wagon for transporting away from the site, but they soon crumbled to dust.

IN LOVE WITH THE ENEMY

At the start of 1783, a Patriot named William Allen was relieved that the war was finally coming to an end. He had

endured many long years of British occupation of Long Island, and had seen his fortunes dwindle during that time. On more than one occasion, Allen had nearly been captured by the British. He had endured heartbreak and sadness as his oldest son was desperately injured in battle. The boy was sent home to rest, but died after some months. Allen's wife also died, likely of a broken heart after tending to her ailing son. Allen's two other sons came back from the war unscathed, and his daughter Molly remained by his side. But he had one more hardship to endure.

In the spring of 1783, toward the very end of the war, British soldiers had been ordered to capture William Allen. Luckily, Allen had heard of this plan and escaped. However, the British remained at his home for some time. Some months after Allen had returned, he discovered that while the enemy had occupied the house, Molly had fallen in love with one of their number. The British soldier's name was Captain John Altman. Enraged, Allen told his daughter she would have to stop seeing Altman. Molly told her father to be reasonable, and reminded him that the war had ended, and that after all her beau Captain Altman had never really wanted to fight in the first place. Allen could not be swayed; for his daughter to be in love with the enemy was an outrage. Molly was not so easily dissuaded. She would not agree to stop seeing the British captain. So Allen called for his sons, and told them to stand guard in front of Molly's room until the British troops departed from New York on November 25. He gave them orders to shoot if any of the "enemy" appeared. Though

distraught at first, Molly soon appeared to calm down, but what her father did not know was that a couple of former slaves living on the property were secretly plotting with Molly and Captain Altman.

One night, the enemy lover got a ladder and climbed up to Molly's window. Molly quickly grabbed her belongings while her brother slept outside her door. She squeezed through the window and down the ladder and the two rode off. The next morning, William Allen rode toward New York in search of his daughter. Luckily, he found John Altman in Brooklyn and demanded to see his daughter. She was already onboard a ship set to sail for England the next day. Allen ordered Altman to take him to her. He knew what he had to do. He offered to split his property and give the young couple some land if Altman promised to stay in America and resign his commission. The couple accepted the offer and remained in America.

Revolutionary Tit for Tat

In May 1779, the midst of the Revolutionary War, the American Major-General Silliman lay sleeping in his bed in Fairfield, Connecticut. He had no idea that a small company of British men had sailed across the sound from Long Island in a whaleboat, seeking to take him prisoner. Around midnight, a party of eight men arrived at Silliman's home. One of the men was a carpenter who had worked

for Silliman and was familiar with his home. The racket of soldiers trying to break in through the front door awakened the whole family. Silliman grabbed a musket and investigated. Through the nearby window, he could see the marauders and aimed his gun at them, but it misfired. The men broke through the window and grabbed Silliman. They told him he was a prisoner of war. He was allowed to get dressed, after which they took him and his oldest son back to the waiting boat and rowed back to Long Island.

When they got to Lloyd's Neck, the prisoners were about to be thrown into the guardhouse when Silliman asked, "Is this how you treat prisoners of my rank?" The reply was, "We do not consider you in the same light as we should consider a continental [European] general." Silliman thought about this statement and replied, "How then will you view me when an exchange be proposed?" and thus he was saved from staying in the tiny guardhouse. He was later taken to New York City and then Flatbush.

Meanwhile, the Americans wanted Silliman back, but they had no prisoner of equivalent rank to offer. So they decided to go on a raid of their own to obtain a prisoner. They selected Judge Thomas Jones of Fort Neck (Massapequa; coincidentally, this Thomas Jones was the grandson of the "Pirate" Thomas Jones mentioned earlier). That November, twenty-five American men crossed the Long Island Sound from Connecticut and landed at Stony Brook. They marched directly to the judge's house, a distance of fifty-two miles. They discovered Jones was in the midst of a party at his

house, and luckily the noise prevented anyone from noticing their approach. They knocked at the door and the judge himself answered. They took him prisoner immediately, no one else at the party the wiser, and marched him through the woods for three days until they reached the boat. He was taken to the Silliman home, where Mrs. Silliman cheerily served him breakfast. He spent a few days at the Silliman home, and though the hostess was gracious, the judge was in foul spirits. Perhaps he knew what lay ahead; it took a full six months for an exchange to be conducted. Silliman was sent by boat across the sound; he met up with Judge Jones and they had dinner together before each one proceeded home. Things ended well for Silliman, who was given a hero's reception. But for the Tory Thomas Jones, his estate was taken away and when the war ended he fled for England.

The Hermit of Half Hollows

During the late nineteenth century, a curious old hermit lived in the woods about a mile north of the village of Deer Park. The old man, who referred to himself by the enigmatic name of "Day," lived in a little cave-like hut he had fashioned for himself. His cave, about eight feet by four feet, was made from oak poles with a roof of sod and branches. He seldom left the "comfort" of this primitive cavern except to get food. He raised fruit and vegetables on a nearby hillside. In the fall, he also searched the forest for chestnuts, which he sold to the

locals, interacting with people only begrudgingly because it made him uneasy. He had no interest in giving up his solitary life and naturally he did not care much for interaction with other people. One of his great joys was taming the local birds, and when he called them they came, and landed nearby or ate food from his hand. In inclement weather, when the birds

were not around, mice and squirrels became his pets and valued friends. The old man had piercing black eyes and a big mustache. He had dark hair streaked with gray.

Though secluded from the world, Day was actually well educated. When interviewed in 1871, he had in his possession a Bible and several hymn books, and could speak with knowledge about several subjects. Besides books, his only other possessions were a wood stove, a stool and a few barrels. He did not wish to talk of his past. The only thing that was known about him among the villagers was that long ago he used to be a schoolteacher. According to Day, he had once been "addicted to profanity." He eventually saw the error of his ways and became a hermit. He believed that he was fulfilling the Creator's will by living in seclusion, and that if the Lord wanted him in the world, He would send him there.

WIFE SWAP SCANDAL HITS HEMPSTEAD

In the wee hours one Friday morning in July 1846, a most scandalous event took place in Hempstead Branch. The normally sleepy little hamlet was shaken by wild rumors that were soon confirmed to be true. A married woman named Mrs. Flowers had eloped with a teacher named George Hudson, and a second married woman named Mrs. Jones had eloped with a carpenter named Joshua Eustis. To add further intrigue to the scandal, both of the men were married as well. Mr. Eustis took some silver spoons, his wife's

treasured silver pencil, some clothes and more than $300 in cash before he left Mrs. Eustis. Mr. Hudson did not take anything from his wife, but a neighbor reported stolen shirts, silver spoons and money, which Mr. Hudson was suspected of stealing.

Mrs. Jones was awake that night when her husband came home late. When he asked her why she was still wide awake, she claimed it was too warm to sleep. They went to bed and he soon fell asleep. But though Mrs. Jones lay still, she was not asleep. She was waiting. As soon as she heard the noise of a wagon pulling up outside, she flew down the stairs to meet her lover. In her haste, she forgot the clothes she had packed in advance. By the time her husband woke, she was gone; all he had left of her were some forgotten clothes. The sneaky foursome went in darkness to New York City by wagon, where they got on a boat and headed up the Hudson River to Albany. From Albany they proceeded to Rochester.

The sheriff of Queens County set out three days later after the fugitives, going all the way to Albany, but returned with no news after a few days' journey. Her health and well-being shattered by the shock of losing her husband, Mrs. Eustis died of grief shortly afterward. Finally, Mr. Flowers and Mr. Jones traveled to Rochester in search of their missing wives and had all four of the characters arrested on a charge of disorderly conduct. They were brought back to Albany, where the disorderly charge was deemed insufficient to hold the fugitives captive. What were the husbands to do? They decided to have the lot of them charged with stealing

the clothes that their wives were wearing, which by law was their property as the husbands. The charge may have stuck for Mr. Hudson and Mr. Eustis, but the women had to be released since it was determined they could not legally be charged with stealing from their own husbands.

ANOTHER ELOPEMENT

When Mr. and Mrs. Carpenter appeared in a Long Island courtroom for their divorce hearing in 1875, a friend named Charles Lewry participated. Lewry, a cigar dealer from Jamaica and formerly of Suffolk County, told the court he was friendly with both of the Carpenters. The truth was that he had actually been scheming with Mrs. Carpenter to get her a divorce. When a divorce was granted, the former Mrs. Carpenter moved to Brooklyn. Shortly afterward her ex-husband died of a suspected suicide. Not long after that, Lewry abandoned his own family and eloped with the former Mrs. Carpenter. Meanwhile, the abandoned Mrs. Lewry was not content to let her husband get away. She tracked him to Trenton, New Jersey, where Mrs. Carpenter was posing as his wife. When he found out his real wife was onto him, Lewry moved to Orange, New Jersey. The determined Mrs. Lewry tracked him down to a picnic there, and then staked out his apartment, but Lewry gave her the slip again. It was not recorded what happened next, but it seems likely that Mrs. Lewry prevailed.

The Train Won

From an 1892 Long Island newspaper: "Michael Scally of Babylon, and a train met on the rail, the train seemed to have the 'right of way' and Mr. Scally was buried Sunday."

A Real Shot in the Arm

In August 1878, several couples from Hartford, Connecticut, were visiting Gardiner's Island for some summertime fishing and hunting. One unlucky man was walking along with his gun tucked under his arm when, unfortunately, the gun went off and he was injured in the wrist and palm. The injured man immediately traveled by boat back to Orient Point and then by wagon to Greenport, where a doctor pronounced it only a flesh wound. The embarrassed man, done with his Long Island vacation, went immediately back to his home in Connecticut.

Ghost on a Steeple

In December 1885, a mischievous ghost appeared at Lawrence, entertaining and frightening the many people who saw it climb frantically up and down the steeple of the Methodist Episcopal church there. It even remained perched

at the very top of the steeple for some time. It was also known to play a game of hide-and-seek in the latticework of the bell tower and dance on the church's slanted roof. It appeared to increase and decrease in size depending on the viewer's vantage point. The ghost even rang the church bells at odd hours, including ten o'clock on a Saturday night. Some supposed that the specter was the ghost of a former sexton. One night, the church sexton noticed that the bell rope had been broken, but was astonished when the next day the rope was whole again. The playful ghost was even reported to follow some of the parishioners home and stay with them a while. After its antics at the church, the ghost was said to disappear in the general direction of the neighboring graveyard. An old Irishman obtained a candle blessed by a Catholic priest in a neighboring town, intending to bring it into the Methodist Episcopal church and investigate at night, but he was ordered not to go near the church with his Catholic candle.

Death of an Old Soldier

The last survivor of the Revolutionary War's famous Battle of Lexington (April 19, 1776) was supposed to be Captain Joel Cook, who died at the age of ninety-one in Babylon, December 1851. He was only sixteen years old when he first joined the army in 1776. Captain Cook had also fought at the Battle of Bunker Hill, and later served with distinction during the War of 1812. Captain Cook had moved to Babylon in 1849 after many years of living in Yonkers, where the residents had bestowed upon the beloved veteran a gold medal in 1845.

Another Old Soldier

One of the last surviving veterans of the Revolution on Long Island died in July 1853 at the age of ninety-six. Henry de Camp was born in New Jersey and joined the army as a very young man. He later became a carpenter and moved to Troy, New York. He then moved to Greenport, and had been a resident there since about 1828. He was survived by four children, fourteen grandchildren, twenty-three great-grandchildren and one great-great-grandchild.

A FLAME-BREATHING GHOST JOCKEY

In December 1885, a ghostly phenomenon caused quite a sensation among the residents of Woodhaven. The spooky specter appeared every night at the old Centerville horse racing track for a ghastly and entertaining performance. Rumors circulated that the apparition was the ghost of either of two jockeys who had been murdered at the track some time before. For some reason, the ghost was on a strict schedule, appearing at 9:45 p.m. and leaving at 11:12 p.m.

The first act of the bizarre spectral show was at the old stables. From the former stables, the ghost followed the road to where a hotel formerly stood near the track. It remained at that spot for some minutes before heading to the track, mimicking the jockeys who used to stop there for a drink before a race. Without touching the ground, the ghost reportedly raced around the track at a breakneck speed, as speedy as the fastest racehorse. The ghost was said to spit fire "like a foundry chimney" and leave a harsh sulphurous smell in its wake. After the "race" the ghost retraced its route and wound up back at the site of the stables again. This eerie phenomenon was not just the product of drunken imagination; the ghost was seen by at least fifty people on one night alone. Though the spectators could not agree on the ghost's garb, the onlookers all agreed on one thing: whenever the ghost came to a halt, it always cried, "Whoa!"

Help for an Old Veteran

In May 1888, ninety-two-year-old General Abraham Dalley of Brooklyn was said to be one of only two remaining survivors of the War of 1812 in New York state. A third survivor, also in Brooklyn, had died earlier that year at the age of ninety. At that time, General Dalley was reported to be living off a meager $8-per-month government pension and was in dire need of money. It was reported that without the assistance of some of his friends, he would have wasted away to nothing

for lack of food. At one point, his friends and fellow veterans held a fundraiser for the old soldier. The still spry General Dalley even traveled to Albany to try to get more aid from the government, but was unsuccessful. Instead, it was suggested that the government of Brooklyn give him up to $600 per year from any budget surplus it had. When Dalley finally passed away in February 1893, he was in his ninety-seventh year. He had joined the army at the age of sixteen and been married at the age of twenty. He was survived by sixty-nine descendants, including thirteen children.

Town Name for Sale

When the Reverend Minot Morgan went to Speonk in 1894 to be the pastor of the church there, he took an immediate disliking to the name of the settlement. In February 1895, Reverend Morgan went to his parishioners with a petition to the postmaster general to officially change the name of the post office there, thus changing the name of the village. Many people in Speonk wished to keep the name the same, and so a counter petition was circulated. Reverend Morgan decided upon a new course of action. He approached a wealthy summer resident of the village named Charles Remsen, and told him that if he were to build a library, church or other public building as a gift to the village (something he had been contemplating anyway), the settlement would be renamed in his honor. Remsen agreed to this proposition as long as

the villagers did not object. Reverend Morgan revised his petition and told the citizens they would not get this generous gift unless the village name was changed. Now more people signed the petition, but the opposition mounted another campaign against a name change. Reverend Morgan brought his petition to the postmaster's office in Washington, D.C. In October 1895, the post office was renamed Remsenburg. Keeping up his end of the bargain, Remsen's gift, a new church, was completed in September 1896. But contrary to Morgan's wishes, the name Speonk did not vanish; today both names are still in use in the area.

SALVAGED CARGO

Over the years, Long Islanders living along the shore have salvaged a wide variety of cargo from shipwrecks. After the survivors (if any) were rescued, valuable cargo would often wash ashore. Among the wrecks and their interesting cargo that was salvaged by beachcombers: the *Amsterdam*, wrecked off Montauk Point in October 1867, carried fruit, wine and lead. The *Chippewa*, wrecked off Ditch Plains in June 1908, carried hundreds of tons of watermelons, as well as some live ostriches and alligators. The *Louis Philippe*, wrecked off Bridgehampton in April 1842, had a cargo of rosebushes and trees. The *George Appold*, wrecked off Montauk Point in January 1889, carried calico cloth, shoes with copper toes and rum. The *Lewis King*, wrecked off Ditch Plains

in December 1887, carried many hundreds of pounds of dates. The *Great Western*, wrecked off Lone Hill in March 1876, and the *Lamington*, off Blue Point in February 1896, both carried oranges. The *Rosina*, wrecked off Moriches in February 1871, carried brandy. The *Robert*, wrecked off Bridgehampton in 1855, carried hundreds of casks of Madeira wine. The *Vincenzo Bonano*, wrecked off Point O' Woods in June 1906, carried a cargo of lemons. The *Alexandre La Valley*, wrecked off Southampton in January 1874, carried French wine and brandy. The *Mesopotami*, wrecked off Hampton Bay in November 1863, carried peanuts. The *Europa*, wrecked off Quogue in March 1886, carried pipes, matches and music boxes. The water ruined cargo such as salt, but cargo such as coal could be salvaged. Exotic fruit that washed ashore was a special treat for the residents of Long Island.

SOLDIER AT THE AGE OF TWELVE

In August 1897, one of the country's last surviving veterans of the War of 1812 died in Brooklyn in his ninety-eighth year. Lieutenant Michael Moore was born on July 4, 1800. His father had been a soldier in the Revolution. Instilled with the patriotic spirit at a young age, he and his older brother joined the army when the War of 1812 started. He began his career as a drummer boy but soon fought in several skirmishes, including the battle of Fort George, Canada, at

the age of twelve (nearly two months before his thirteenth birthday). His sixty-year career in the army ended in 1872 when he retired. The year he died was the eighty-fifth anniversary of his entering the service.

LAST OF THE 1812ERS

The nation's last survivor of the War of 1812 was buried in Brooklyn. Hiram Cronk of Utica, New York, died in May 1905 at the age of 105. He had enlisted in the army at the age of 14. He was buried in Cypress Hills Cemetery with full honors.

TOO EARLY FOR HOME SHOPPING

Charles E. Willis, a resident of Oyster Bay, had what he believed to be a great invention. In April 1891, the fifty-nine-year-old pipe manufacturer received United States patent number 451,217 for his "Combination Paper-Cutter." This handy-dandy tool could be used as a paper cutter, letter weigher, ink ruler, letter opener, stencil and bookmark. He envisioned this item made of tin, bronze or celluloid (the ancestor of modern plastic). In his patent application, Willis explained that in order to use the invention as a postal scale, all you had to do was place it on a desktop and place a letter on the blade to see whether it was under or over an

ounce in weight. If you put a silver dollar on the blade as a counterweight, the scale could measure two ounces. It is only too bad that Willis missed the era of the home shopping channels, because the item would surely have sold well "as seen on TV."

SHIPWRECKS OF MONTAUK

Between about 1840 and 1870, numerous ships have been wrecked on Montauk Point. These disasters include the schooner *Triumph*, the whaling ship *Forrester*, the brig *Marcellus*, the bark *Algea*, the light boat *Nantucket*, the brig *Flying Cloud*, the ship *John Milton* and the steamer *Amsterdam*. The worst of the lot was the *John Milton*. Sailing from the South Pacific and loaded with manure, she crashed during a snowstorm in January 1858.

FLORAL PARK HAD BIRDS TOO

John Lewis Childs, the founder of Floral Park, created a huge nursery and seed business there during the late nineteenth century. At times, he received as many as 8,000 to 10,000 order letters per day. He began his own printing press so he could print the catalogues that went to 500,000 customers twice a year. His printing press was capable of printing and folding 80,000 catalogues per day. Besides maintaining a

strong interest in flowers, Childs was also a top expert on birds. In his office at Floral Park, he had what was said to be the largest private collection of mounted North American birds in the country. By 1907, he had birds from 1,100 different species and subspecies. He also had a magnificent collection of 1,030 species of bird eggs, many with their nests intact. In addition, he also collected butterflies, beetles, shells, rocks and minerals.

LAST CIVIL WAR VETERANS

The last surviving Civil War veterans in Queens and Nassau Counties died in 1944 within one month of each other. Ringgold Carman of Flushing, who had enlisted as a drummer boy, died at the age of one hundred in June. He claimed to have been present in Ford's Theater when Lincoln was assassinated. Joseph Wheeler of Hempstead died in July, at the age of ninety-seven.

STRAWBERRY PICKER

Miss Georgiana Purick, a young woman of German descent, was declared the strawberry picking champion of Suffolk County in the summer of 1891. She impressed many by picking 212 quarts of the ripe red berries in a single day, amounting to more than four thousand strawberries.

DEAD DOG ISLAND

Three and a quarter miles off the shore at Rockaway Beach lies an island known as Barren Island. In the early nineteenth century, an infamous pirate named Charles Gibb landed there and buried a treasure of nearly $5,000 worth of Mexican and Spanish gold and silver coins in the sand. A man named Johnson discovered this treasure chest in 1878, and found much of the loot had been turned black from exposure to water and the elements.

With the exception of the treasure, Barren Island really lived up to its name. For many years it was the home to several factories that processed all the dead cats, dogs and horses from New York City. Large bones could be salvaged and sold to knife manufacturers for use as handles. There was also a fish boiling operation, which boiled a million mossbunker fish per week, the byproducts of which were used for fertilizer. When a reporter visited in 1877, he found about one hundred loose dogs on the island, some quite dangerous looking. Some of the dogs had attacked and nearly killed a fisherman a few years earlier. One worker sat reading a book with fifty mosquitoes on his face and neck. During the peak season, there were about 280 inhabitants, including 10 women and some children. The stench on the island was overpowering, but even from Rockaway, it was said that one could smell the "decayed horses or putrid dogs." For several hundred yards around parts of the island, the water was coated with an oily substance.

The island and its inhabitants were parodied in an 1853 book:

> *Your moral perceptions are as blunt as the end of a crowbar, and your ideas of things in general are as stunted as those dwarfish cedars that surround you…the impartial moon sheds the same beams upon your sheep-pen-looking shanties as upon our magnificent mansions. Still, you grope in moral and intellectual darkness….Natives of Barren Island: though you are a rough-looking set, and your numbers be few, still you are no less valuable on such account. The hand Divine that moulded you, also manufactured me, consequently I am your brother, and as a brother I advise you to quit drinking potato-whisky and eating fish-hawks—to put bonnets upon the heads of your wives and shoes upon the feet of your children.*

By the early twentieth century, a garbage reducing plant had been constructed there. Inspectors in 1902 found miserable conditions on the island, with garbage not being handled properly. The inspectors also noticed that the wastewater from the garbage was being released directly into the bay. New York City sent five hundred tons of garbage to the island per day. The garbage was cooked for eight hours, and came out of the process as a pulp. Water was squeezed out and the grease was separated and then sent to Belgium to be used for making soap. The fiber left over was dried and then used to fertilize tobacco crops in the South.

An Armed Ghost

A remarkable sight greeted the villagers in Sag Harbor in November 1895. That autumn, many citizens came across a ghost that appeared evenings on some of the less busy roads and byways of the place. This was no ordinary ghost, for it was reported by one witness to be wearing a tall hat and carrying an old musket. As a result, the men of the village felt they too should be armed, and walked the streets with guns, firing at the ghost upon spotting it. The women of the village were too frightened to be out without an escort. One evening, a twenty-one-year-old man named John Tabor was walking along Union Street when the ghost suddenly popped out from behind some bushes. The frightened and unarmed man ran home, reporting that the apparition was a daunting height of about six feet tall. A sixteen-year-old boy named Bruce Sweezey was on his way home one night when he came upon the ghost. Having heard about this spook, he was carrying a revolver in his pocket. He prepared to remove the gun from his pocket and shoot the otherworldly thing, when he accidentally shot himself in the hand, shattering a bone and causing a serious injury. A ghost hunting posse was to be gathered to find and eliminate the specter.

Shootout at the Farm

One Friday night in November 1877, an old farmer named James Dennis, who lived along Hempstead Turnpike between Franklin Square and Elmont, heard a noise outside. He got his revolver and steeled himself to go outside and see what the trouble was. He saw a man skulking about his corn stores. He fired at the intruder, but missed. This trespasser also had a gun, and returned the fire. His bullet went through farmer Dennis's kitchen window. Next the farmer spotted a man emerging from his stables, fired and was fired upon. Just when he thought it couldn't get any worse, a third intruder appeared. Farmer Dennis fired at the third man, hitting him. The intruders ran for it. Farmer Dennis found a bag with various pilfered tools that the robbers left behind. Unfortunately, the next night, the farmer's barn was set ablaze, presumably by the same thieves.

First Aerial Submarine Hunt

During World War I, Americans living along the East Coast were alarmed to read about the new German U-boats, or submarines, that were prowling the waters of the Atlantic Ocean. Long Islanders recalled reading about one instance when a U-boat had successfully crossed the Atlantic Ocean, sunk six ships and disappeared without being caught. So

when on March 26, 1917, the lighthouse keeper at Quogue reported two U-boats at Montauk Point (near the entrance to the Long Island Sound), there was no small concern. Unfortunately, the nearest available naval seaplanes were in Florida at the time. It was left to civilian aviators to answer the call and go on patrol in the skies, in what was to be the first aerial submarine hunt in American history. Four pilots (A.W. Briggs, Bertrand Acosta, A. Livingston Allen and Leonard Bonney) and their observers left from the Mineola airfield the next morning, in the midst of a severe gale and rainstorm. Their goal was to patrol the waters of the sound from Oyster Bay to Montauk Point in search of enemy submarines. Acosta and Briggs were out three days; they did not return to Mineola in the meantime, and only landed when necessary. Briggs flew a distance of 124 miles through the heavy rainstorm. After three days of intensive searching, the crews had found nothing. Then the navy issued a bulletin. It had figured out the identity of the alleged U-boats. They were simply two patrol motor boats. According to the builder of the boats, he had been told they looked very much like submarines.

RABBIT SEASON?

A sensational rabbit scandal, if there could be such a thing, rocked Long Island in November 1888. The wealthy sporting enthusiast August Belmont Jr. (1851–1924) and some of his

friends belonged to the new Hempstead Coursing Club. This club introduced a controversial sport from England—coursing rabbits. Rabbits were released and dogs were set upon them to find and kill them. The Society for the Prevention of Cruelty to Animals (SPCA) got wind of this, and had Belmont arrested under Section 655 of the 1881 New York State Penal Code. A witness to one rabbit hunt, the superintendent of the SPCA, described watching two dogs give chase after a newly released rabbit. The witness saw the first dog grab the rabbit's head in its mouth and the second dog bite the rabbit on the back, after which the dogs pulled the rabbit between them until it died. In his court testimony, Belmont insisted that coursing rabbits was more humane than hunting them with guns, and that it was an accepted and established sport in England. A Hempstead jury found Belmont and his associates innocent, and it was reported that there was "great cheering" in the courtroom. It was good news for Belmont, but bad news for seventy rabbits penned up at Hempstead. The club members were arrested two more times that year, but both times the jury acquitted them.

FREEPORT "GHOST" CATCHERS

In April 1845, Freeport (then called Raynortown) was haunted by some very vocal spooks. There were regularly cries, animal calls and ghostly songs that scared and vexed

the locals. Finally, two men decided they'd had enough. Jim Raynor and Tom Southard, both yeomen, set out to hunt down the "ghosts." They staked out the area, but found that each time they did so, no ghosts appeared. They figured that the spirits must have been tipped off as to their plans, so they came up with another idea. They stretched a rope across the only entrance to a house that the ghosts sometimes frequented. From inside the house, they gave the ghosts an alarm. The phantoms ran out and tripped over the rope. One of them escaped, but they pounced on the other one and captured him. He turned out to be just a local thrill seeker. The captors, angry at his pranks, roughed him up a bit and then took him to court still in his ghostly garb. He was charged with disturbing the peace and set free on the promise to do it no more. The repentant specter agreed, and there were no further disturbances in that neighborhood.

A BIG OOPS!

In April 1644, seven Indians were arrested at Hempstead, charged with killing two or three pigs. They were thrown in a cellar and held there. The man in charge at Hempstead, Reverend Fordham, sent word of the crime to Governor Kieft in New Amsterdam. Kieft sent about fifteen soldiers to Hempstead. They went into the cellar, killed three of the seven Indians and then took the other four Indians

into a sailboat. Two of the Indians were towed behind the boat by a rope around their necks until they drowned. The other two were detained further before being killed by the knife-wielding soldiers. These Indians were permitted to perform a religious dance before their deaths. It was later discovered that some Englishmen, not the Indians, had killed the pigs.

THE FOX WAS A CAT, AND THE CAT RODE A HORSE

The Meadowbrook Hunt Club, headquartered near Westbury Village, had an interesting fox hunt on the Hempstead Plains in November 1897. The dogs set off after a fox, lost the scent and then picked it up again. Or so the riders thought. The hunting dogs were actually chasing after an oversized cat, but it took them a while to realize it. One rider called it "the queerest looking fox I ever saw." The dogs cornered the cat against a tall hedge. The cat raised its tail as if to fight, but it had no chance against the hunting hounds. Once they realized their mistake, the riders dismounted their horses and called the dogs off, with great difficulty. But the frightened cat did not slink away. She was still beside herself. She leapt upon the neck of one of the horses and clung there with her claws. The horse immediately became agitated and escaped from its groom, who was standing nearby. The horse ran across the fields at a frantic pace, with the cat hanging on for dear life. Along

the way, the horse jumped over three fences. Several grooms went after the errant horse. After two miles, the horse was finally subdued, the cat still clinging to its neck.

BE NICE AND YOU'LL GET A PIECE OF CLOTH

In August 1647, delegates from Hempstead appeared in New Amsterdam with a disturbing report. Rumors were flying that the Indians of the Hempstead area were being told by their counterparts in Connecticut to make an attack on Hempstead and destroy the village. It was decided that some official or other should make a visit to Hempstead to renew the friendship and prevent an attack with the gift of "a piece of cloth and some trifles" for the local chief.

NO WITCH IN MY BACKYARD

In 1670, a woman named Katharine Harison decided to make a fresh start of her life and move to Jamaica. She'd had a bit of a bad stretch and was looking to make a clean break with her old life. When the citizens of Jamaica found out about her arrival, they were not pleased. It seems that Harison was an alleged witch. She had lived in Wethersfield, Connecticut, for nineteen years, had most recently been in prison at Hartford for one year and was released on her promise to move away from Connecticut and live elsewhere.

The citizens' petition was granted and the accused witch was not allowed to settle in Jamaica.

LESS INSANE THAN NEW JERSEY

In 1840, it was reported that there were twenty-four people considered to be insane or idiots in Suffolk County. This compared favorably with Monmouth County, New Jersey, which had forty-five insane or idiots.

BIG PIGS

In 1831 and 1832, December was apparently big pig month on Long Island. In December 1831, David Bedell of Hempstead killed a nine-month-old pig that weighed 412 pounds and Daniel Combs killed another that weighed 401 pounds. John and Coe Jackson of Jerusalem slaughtered a hog that weighed 831 pounds. In December 1832, Mrs. Rapelye of Newtown had two two-year-old hogs that weighed about 1,300 pounds each.

HORSE RACE ERASED

In May 1768, one thousand excited spectators showed up to watch a Long Island horse race that had been promoted

and advertised. Entry into the Beaver Pond Races was free for any horse less than four years old. The horses were to run three times around the pond. The prize was a plate worth twenty pounds. Three horses were needed to race, but only two horses appeared: Captain Rutgers's Queen Kate and Mr. Heard's Lady Legs. The spectators were mightily disappointed and wondered if they would get their nine-shilling admission back.

Snakefest

In December 1829 at Pond Hollow Woods in the town of Oyster Bay, two boys searching for rabbits found more than they bargained for. Under an old tree stump, they were startled to come across no fewer than 130 wriggling black snakes, some of which were six feet in length. Shortly after their discovery, all the snakes were killed.

Two Notable Deaths

In about 1748, the well-known Colonel Thomas Hicks of Hempstead died at the age of ninety. He left behind more than three hundred descendants. Jacob Blackwell of Newtown, age fifty-two, also died about the same time. Mr. Blackwell was six foot, two inches and weighed 439 pounds in 1745. People said he had gained much more weight

before his death, but it was not known how much, because Mr. Blackwell did not agree to be weighed a second time.

Revolutionary Treasure

In August 1809, a schoolboy named John Riker (son of Daniel Riker and member of an old-time Newtown family) found a treasure consisting of a bag of gold worth $840. It was determined that the treasure had belonged to John Kearns, a schoolmaster, and was hidden during the Revolution to keep it out of the hands of marauding British soldiers.

Suicides over $50 and $50,000

By the 1880s, a certain house on Front Street in Hempstead had gained a reputation among the locals as a "hoodoo" house. The house was built in 1844 by a stone mason named Cannan Doolan. After a few years, the builder and his wife both died and the home was occupied by their son Valentine, also a mason. This Valentine was known as a miser who wore clothes until they came apart at the seams. His main hobby was feeding a voracious appetite for watermelons. Valentine also dabbled in real estate. In 1884, he let a house to a man named Mettler for occupancy April 1, but the then-occupants of the house changed their minds and decided to

stay on further. Valentine asked for Mettler's understanding in the matter, but Mettler would only release him from the agreement for $50, which Valentine begrudgingly paid. This $50 gnawed at Valentine's soul to such a degree that he became obsessed with it, and then became severely depressed. One night, Valentine Doolan went into his backyard, stuck his head into a pond of water and drowned himself. Strangely, Valentine Doolan had $4,000 in the bank, nearly $5,000 bricked and hidden in part of the house and another $20,000 in real estate. Because Doolan died with no will, there arose a fight over his assets. When all the lawyers and legal fees were paid, each prospective heir received the princely sum of $1.54. As for the house, it remained vacant for a couple of years on account of the rumors of a ghost spotted eating spectral watermelons at night.

A later occupant of the house was John Griscom, an inventor who was upset over the $50,000 he had spent in designing a brooding house for chickens. The invention was registered for a patent in June 1885, but it did not work very well, and not long after Mr. Griscom killed himself.

THE HEMPSTEAD METEOR

On the evening of August 1, 1838, a shower of falling stars was visible on Long Island. One of these meteors fell to the ground in Hempstead South and buried itself in the ground near the home of Tredwell Smith. According to

local spectators, it flashed as brightly as lightning and left a streak of light suspended in the air. When curious onlookers ventured to the spot in the field where the space rock had fallen, they noticed it was already gone. They were told that a local named Epentus Smith had taken it. So the curious folk went to Epentus and asked him. He confirmed that he did have it; he'd locked it in his wagon house for safekeeping. He claimed that it was not rock, but was made of iron. He said it was a great curiosity and that he expected to get a good amount of money for it, but he did not offer to show it to the neighbors. The Hempstead meteor was subsequently said to

have been on display for two years at the Queens County agricultural fair.

A SEVERE WINTER

In the winter of 1835–36, Suffolk County received heavy snows. The first snow fell on November 22, and it snowed often over the next four months. The average depth of snow was three to four feet in most places, and drifts of six to ten feet in some spots. There was no thaw until March 25, but another snowstorm came on April 13. There were still substantial snowdrifts in the fields as late as April 25.

PIRATE MAGNET

John Gardiner, owner of Gardiner's Island, had already lived through an ordeal with the infamous Captain Kidd. By 1728, he thought his adventures with pirates were over; the Kidd incident had been nearly thirty years before, when Gardiner was a young man. However, one night in September 1728, a Spanish schooner loaded with pirates anchored off the island, and eighty armed pirates rowed to the shore. Luckily, the women and children were able to escape to the mainland before the pirates arrived at the manor house. They ransacked the island and took many of his prized possessions and killed Gardiner's animals.

After a stay of a few terrible days on the island, the pirates tied poor John Gardiner to a tree on their way out.

GOOD GENES

According to the United States Census, the oldest residents of Queens, Brooklyn and Suffolk Counties in 1880 were all African Americans. Daniel Green was a 100-year-old man living in Yaphank. Caroline Townsend was a widow living with her daughter in Queens at the age of 106. Nancy Remson, originally from New Jersey, lived in Brooklyn with her granddaughter at the age of 109. In 1870, the oldest folks in Brooklyn and Suffolk were also African Americans, ages 105 and 103, respectively.

FISH MEET SUCCESS

Samuel Mitchill and his uncle Uriah Mitchill, sheriff of Queens County, lived near Lake Success. In 1790, they traveled by wagon to Ronkonkoma Pond in Suffolk County, some forty miles away. They had it in their minds to bring some yellow perch back to Success Pond. They caught dozens of fish and selected about thirty-six of the ones least injured by the hooks in their mouths. These they put into the wagon and rode back to Queens. When they got to Success Pond, they were able to get thirty-four

of the fish into the pond. Within two years, the fish had multiplied and were thriving in Success Pond.

THE OLD SISTERS OF RIVERHEAD

For many years, two elderly widowed sisters named Nancy Hallock and Maria Edwards lived together in a house on Roanoke Avenue in Riverhead. In 1894, it was reported that the two vigorous ladies, ages ninety and ninety-two, still did all their own housework and regularly could be seen together at church on Sundays. In 1899, they were still active, though a year earlier they finally accepted help with their housework. Daughters of a jail keeper, they had lived in the Riverhead Courthouse through their youth. This accounted for the great adventure of Maria's life: when she was about twenty-two, she had tried to stop a prisoner from escaping from the courthouse jail and broke her arm in the struggle. Nancy died in November 1899 at the age of ninety-seven, and Maria died in April 1900, at the age of one hundred.

STABBED OVER PEN AND PAPER

Colonel Benjamin Birdsall, born in the town of Hempstead in 1736, was one of Long Island's heroes of the Revolution. When it was clear that the British were about to invade

Long Island, Birdsall gathered sixty volunteers and headed to Brooklyn to engage in battle. Later, while attempting to recapture an American ship that the British had seized in the Long Island Sound, Birdsall was captured. He was thrown in jail and treated rather cruelly. When he asked for a pen, some ink and a sheet of paper to write to his family and inform them that he was a prisoner, his request was refused. Birdsall protested and his captor became angered and drew a sword. The captor thrust the blade into Birdsall's shoulder. He was left in his jail cell to dress his own bleeding wound with his own linen, with no assistance or medical attention. Happily, he survived captivity and after the war went back to Hempstead a hero.

TO THE COW'S UDDER SURPRISE

In April 1661, the town of Hempstead voted and agreed to hire a cow keeper who would watch over all the town's cows for a period of one year, at a salary of eleven pounds. According to the minutes of the town meetings, "The town being informed of one that milk'd other folk's cows, and having been catched in the act, it was ordered that William Foster should prosecute the offender to the *uttermost*, either here or in Manhattoes."

THE OLD WOMAN WHO LOADED GUNS

During the Revolution, Long Island was a dangerous place for a Patriot to live. Homes were regularly looted or occupied by British forces. One night in Manhasset, a man named Jarvis saw by the moonlight a group of British soldiers on the march toward his house. He knew that by himself, he could not ward off the invaders, but he had assistance from an old lady living in the house. The old woman loaded and reloaded each of his several muskets so that Jarvis could fire at the British from the window. He shot at them as rapidly as he could, being handed loaded weapons by the woman until the British retreated, with several of their men killed or injured.

ESCAPE FROM JUNGLE PARK

In the 1930s, the well-known game hunter, animal trainer and wildlife expert Frank Buck opened a wild animal "Jungle Park" near Amityville. This zoo contained a wide array of exotic species, including lions, tigers, snakes, monkeys and a variety of birds. Admission was twenty-five cents. One day in August 1935, a workman inadvertently left a plank across a moat that surrounded the rhesus monkey exhibit. The monkeys immediately saw their chance. About 150 out of the 570 monkeys escaped over

the plank and out of the animal park. The escapees could be seen cavorting around the area. A Long Island Railroad train had to stop for five minutes on account of a group of 50 monkeys near the tracks. A season pass to the park was offered to anyone who brought a monkey back.

TALE OF TWO HOTELS

The waterfront Marine Pavilion at Far Rockaway was built in 1833 at a cost of $43,000. With 160 rooms, it was one of the largest and most successful hotels on Long Island at the time. The main building was 250 feet long, with wings of 75 feet and 45 feet. The dining room was 80 feet long, and the hotel's waterfront piazza was 235 feet long by 20 feet deep. This hotel was a success until it burned down in 1864. On the other hand, the massive hotel that was built at Rockaway beginning in the late 1870s was a disaster. It cost more than a million dollars to build, and it went through a succession of owners who could not afford it. The hotel was said to be the largest in the world, with 1,700 rooms and a dining room with a capacity of six thousand people. The hotel building was an astounding five city blocks long (one-quarter mile). Its nickname was "the Marine Jumbo." Toward the end of construction, there was no money left to pay the workers, and five hundred angry workers were given worthless scrips instead of cash. The hotel was never fully opened,

and in 1889, the magnificent building was sold for a paltry $29,000 (less than 3 percent of its original cost) and eventually demolished.

BULLY FOR HIM

According to local lore, Richard Smith, the founder of Smithtown, had nothing against horses per se; he simply preferred riding bulls. So frequently was he seen riding a bull that his descendants became known as the "Bull Smiths." Legend has it that in 1665 he bought a plot of land from some Indians. The price would include all the land he could ride around in a day. He had a little trick up his sleeve. As the story goes, he gave his bull, Whisper, some energizing concoction that morning. He rode Whisper far and wide that day, setting the boundaries of his newly acquired land, until the animal finally dropped to the ground of exhaustion. The Indians, shocked at how far Smith rode, nonetheless stuck to their end of the deal. A bronze statue of the bull was placed at a busy Smithtown intersection in 1941.

WHAT KIND OF SMITH ARE YOU?

Because there were many different Smith families on Long Island, each one had its own particular moniker. Besides

the Bull Smiths, there were also the Tangiers Smiths, named so because their founder had been the governor of Tangiers, Algeria; the Rock Smiths, named because they built their home against a large rock that formed the back of their fireplace; and the Blue Smiths, named for the color of a coat worn by their ancestor.

The Hermit of Oak Island

A fisherman named Ebenezer Chichester, born in East Amityville in 1816, for many years lived a quiet life with his wife and children. After the Civil War erupted in 1861, both of his sons, William and Ebenezer Jr., enlisted. It was a great sorrow that one son died in battle, and then the other son decided to remain in the South and never return to Long Island. Ebenezer's wife died heartbroken not long afterward. Ebenezer also had two daughters, but nevertheless, the once content man was left with a very negative view of civilization. Ebenezer Chichester decided to leave the worldly life of Amityville and become a hermit. He removed to Oak Island, an isolated spot off the shore of Amityville. To prevent inundation by the rising tides, he built a mound of dirt twenty feet high, upon which he constructed his new home, a six-foot-square shack. There on Oak Island, Ebenezer the hermit went twenty years without seeing another person. For company he had his pet cats, and he had a selection of

twelve guns with which to shoot birds. He also caught fish for food. Once a lifesaving station was built on the island during the 1880s, he had contact with people again, and it was a lucky thing for him. The great blizzard of March 1888 completely covered his little hut and trapped him there. The men at the lifesaving station came to check on him and dug him out, though he insisted he was stocked with enough provisions to last him until he could get out.

THE MYSTERY MAN OF EASTHAMPTON

In April 1840, a stranger arrived in Easthampton. He was about fifty years of age, spoke with a strong Scottish accent and gave his name as John Wallace. He brought with him a manservant, so clearly he was a man of some means. But Wallace could not be led to speak of his past or from whence he had come. He got a room at the local inn and remained there not a night or two, or even a week or two. He stayed there for all of five years, until his servant decided to head west and make his own life. Wallace then moved in with an Easthampton family. He was well liked among the townsfolk, who thought he was friendly yet reserved. He occasionally received mysterious letters from a lady friend in Scotland, as well as packages containing money and books. He was friendly with the local children and let them study from his books. He contributed to the building of an Episcopal church in Easthampton and

gave money to the poor. Yet despite his friendly nature, he remained something of a hermit and did not travel very much, only going to a neighboring town on occasion.

In December 1870, Wallace died at the age of eighty-one. After he died, his landlady thought it polite to write a letter and mail it to Wallace's mysterious lady friend in Edinburgh. The reply from the woman was brief and formal and shed no further light on the strange man. Some years after his death, the truth about his past finally came out. Wallace had been a respected sheriff living in Edinburgh, Scotland, until one day he was accused of a serious crime. He heard through a friend that a warrant had been issued for his arrest, and he would be taken away the next morning. Wallace fled that night, and found his way to Long Island.

THE WATER SERPENT'S REVENGE

During the 1820s, a boat carrying several Indians was wrecked on the Connecticut shore. The sole survivor was a man named Jim Turnbull, also known as the Water Serpent. He was alive, but injured and unconscious. A farmer named Turner discovered him on the beach and brought him home, where his daughter took care of the Water Serpent. After he regained his health, he left the Turners, with profuse thanks to the farmer and his sweet daughter.

A few months later, the Water Serpent happened to be watching as a ship pulled up anchor and left Peconic Bay. He noted one of the men onboard tossing a large object overboard just as the ship was about to depart. Curious, the Water Serpent decided to swim out into the open water and see what the white object was that had been discarded at the last minute. He had quite a shock when he discovered that it was a body floating in the water. He had an even greater shock when he looked at the face and saw that it was none other than Edith Turner, the girl who had cared for him after his shipwreck. He removed the dagger that had been stuck into her chest, and took the ring off her finger. The Indian found out that the girl had recently run off with a British ex-soldier. The Indian felt certain it was the same man whom he had seen throwing Edith overboard. With the help of the girl's brothers, the Water Serpent hunted down the killer, tracking him to the area of Stamford, Connecticut. When the man's body was eventually found in the woods, his chest was pierced with the very same dagger with which he had killed his lover. According to the legend, the Water Serpent was so dejected after taking his revenge that he died upon the grave of Edith Turner.

A REAL MOUTHFUL

An old Indian name for a place in Montauk was Choppauhshapaugausuck, which meant "place separated

where the outlet of a pond or small stream widens." The Dutch form of the name for Montauk itself was Mirrachtauhacky.

A DISASTER WITH FAMOUS PASSENGERS

The *Seawanhaka* was a steamship that traveled regularly between New York City and Roslyn, Sea Cliff, Sands Point and Glen Cove, carrying a mix of commuters and vacationers. It was passing through the Hell Gate one afternoon in June 1880, near College Point, when it caught fire. The fire spread rapidly. Captain Charles

Smith of Merrick was at the helm. He remained calm and in control. He knew he had to steer his ship toward land, but he had to be careful to avoid the rocky shore and aim for a marshy meadow. Even as the flames licked at his hands, he gripped the wheel, searing heat stifling the air in the pilot house. Some who jumped overboard were drowned; though about fifty lives were lost, two hundred were saved by the captain's actions. Among the passengers who survived the disaster were Charles Dana, the famous editor of the popular newspaper the *New York Sun*; John Harper, New York publisher (Harper and Row); the wealthy S.L.M. Barlow; and future New York City Mayor William Russell Grace.

REMARKABLE RECOVERY

In January 1809, a ship called the *Trial* was wrecked off the north shore of Long Island. Every one of the crew died except for three lucky souls who clung to the rigging for seventeen hours in the cold of winter. The survivors, including a British man named Thomas Eustace, were eventually taken to Northport. There, doctors mulled over the possibility of amputation. All of Eustace's fingers were amputated, along with both legs below the knees. He returned to England and wrote a book about his trials in 1820, called *Shipwreck off Long Island, Near New York: The Adventures of Thomas Eustace*. He married and had two

children, and was able to find employment as the manager of a workhouse in Amersham.

TENDED CORN NEAR BATTLEFIELD

Judy Polhemus of Jamaica, Queens, died at the age of 100 in January 1852. She was said to be hoeing corn at the time of the Revolutionary War's Battle of Long Island in 1776, not far from the battlefield. Her mother lived to 101, her uncle to 100 and her aunt to 102. At the time of her death, her 70-year-old son was reported to be in a poorhouse in Jamaica.

THE WILD MAN OF ROCKAWAY

In November 1885, the recurring sight of a "wild man" at Rockaway Beach shocked the residents and beachgoers. The six-foot-tall man had long hair and whiskers and was typically dressed in a small and ragged brown suit that barely covered his groin. According to a lifeguard named Reinhart, the man was "exceedingly wild." He had been seen dancing on the sand and crouching in the surf, and was known to suddenly disappear from sight. He was spotted near Mrs. Falling's hotel one evening, but when the proprietor's son gave chase, the wild man disappeared into the sea. A search party of several brave men was sent

out to the beach, but could find no trace of anyone. Some folks thought him to be the ghost of a sailor who had died in a nearby wreck, but in the end it turned out this "wild" man was a swimmer who had been hired to advertise a local hotel. He realized he had failed at his job when a posse of locals set out to hunt him down as a menace to society, and decided to call it quits.

Camp Wikoff

During the Spanish-American War, Montauk Point was selected as the ideal spot for a camp to hold men returning from battle in Cuba. The purpose of their stay would be partly to quarantine them to prevent an outbreak of yellow fever among the general population; the other purpose would be to care for those who were sick until they were recovered. In August 1898, Camp Wikoff was created on about fifteen thousand acres of land in the space of a few short weeks. Tents were pitched and numerous facilities were erected, including a hospital, steam laundry and disinfecting facility. Nearly two million feet of lumber were used for storage buildings and tent floors. A fifty-foot-deep well was dug with a capacity of 300,000 gallons per day and a water filtration plant was erected at a cost of $7,000. About 100 nurses were brought in along with doctors, cooks and many other support staff. Four tank cars of spring water were brought in from Jamaica each

day, along with 1,000 oranges and lemons and 2,000 gallons of milk per day. President William McKinley visited on September 3, 1898, and was pleased with the camp. To ensure the soldiers were properly fed, the government ordered extensive supplies, including 2,100 pounds of halibut, 5,000 cans of pickles, 48,000 pounds of lima beans, 21,000 pounds of butter, 10,000 pounds of prunes, 23,000 pounds of oatmeal, 400,000 pounds of ice and 636,000 eggs. Besides the government supplies, the Red Cross also pitched in, supplying 10,344 cans of soup, 2,536 pillowcases, 4,733 pairs of pajamas, 6,554 towels and 10,946 handkerchiefs. A total of 21,870 troops stayed at Camp Wikoff, with about half of those requiring some medical attention. The entire camp was abandoned by the middle of November 1898, less than three months after opening.

TA-RA-RA-BOOM-DE-AY, I'M IN QUARANTINE TO-DAY

By mid-1892, a cholera epidemic had already swept across parts of the world. By August, Hamburg was infected. Unfortunately, so were passenger ships sailing from that German port. Several ships sailed that August and were held in the bay upon arriving at New York. Passengers were quarantined in various places; some were held on Swinburne Island. But where else could passengers be quarantined? The answer was the Surf Hotel, originally

opened on Fire Island during the 1850s. It accommodated hundreds of guests and in its heyday was known for its luxury. The governor of New York purchased the hotel for $210,000, for use as a quarantine for the passengers of the *Normannia*. There were a total of 970 people onboard, half of whom were in steerage. Many of these *Normannia* passengers were first transferred to a boat called the *Stonington*, but the ship was said not to be able to make the voyage, so they then transferred to another boat, the *Cepheus*. This vessel sailed for Fire Island on September 11, but had to turn back because of rough seas. The 500 passengers were crowded onto a vessel that was only meant for 400 people. There was no comfortable place to rest on the ship, nor any food to eat, though the majority of the passengers could not think about food, as they felt seasick. The passengers were brought back to the *Stonington* at two o'clock in the morning, and got a few hours' rest.

The next day, it was back to the *Cepheus* for another attempt at landing on Fire Island. This time, however, the boat was met by an angry mob of people from Islip, Bay Shore and Babylon who did not wish the island to be used for quarantine purposes. Led by a lawyer, they had sought an injunction to prevent the passengers arriving. They proposed "prohibiting such landing under a penalty of $100 for every passenger so landed, and authorized the chairman of the board to appoint fifty special sanitary policemen with full power to prevent by all legal means such landing." This angry crowd prevented the ship

from landing until the injunction arrived from a judge in Brooklyn. The ship had to turn back once again, its passengers weary. The next day, however, the justices of the Supreme Court of Brooklyn met and agreed to dissolve the other judge's injunction. The governor ordered two regiments of the National Guard to be at the ready in case there was trouble at Fire Island. The mob heard about the impending arrival of the troops and dispersed. The ship finally landed at Fire Island, and the exhausted passengers were allowed off and into their quarters at the Surf Hotel. Among the more notable detainees were a United States senator from New Jersey, the editor of the *New York Evening Post* and Lottie Collins, an actress who was known for her hit song "Ta-ra-ra-boom-de-ay."

HOLY COW!

In March 1770, a butcher from Jamaica named Benjamin Carpenter killed a substantial cow. It was reported that the giant animal weighed in at 1,818 pounds.

THAT MOVED INN FEELING

The Webb House in Orient was originally built in 1740 and was the inn of Lieutenant Constant Booth. Colonel George Washington stopped at the inn on his way from

Boston to Virginia in 1757. The first location of the building was Sterling Creek in the village of Sterling (Greenport). Around 1810, it was moved to North Road and was the home of Orange Webb. Then it was moved again, this time by barge to the village of Orient in 1955, where it remains today, a local historic landmark.

THE LIGHTHOUSE AT LITTLE GULL ISLAND

Little Gull Island, located about ten miles off Orient Point, was considered very isolated. It was also considered an ideal spot for a lighthouse, in order to prevent shipwrecks in that dangerous area. A lighthouse was first built there in 1806, and the first keeper had to farm on the meager island (once described as a "mere bank of gravel and boulders not over 100 yards in its greatest length") to feed his family because he was not able to get to the mainland often enough. The keeper, Israel Rogers, experienced no major problems, other than a feeling of isolation. The next keeper, Rogers's son-in-law Giles Holt, did experience a few problems during his tenure. During the War of 1812, a British commodore and his men landed at the island and dismantled the lights in the lighthouse. Then the hurricane of 1815 caused major damage. Finally, Holt left under pressure from his wife, who could no longer stand being in harm's way. In 1816, the federal government authorized $30,000 for repairs to the battered place.

NOT WORTH KILLING A SQUIRREL ANYMORE

Some citizens in Queens County were alarmed at the amount of money coming out of government coffers to pay pest hunters. In November 1712, Samuel Baylis led his neighbors in offering a petition to decrease the reward amounts for killing adult or young squirrels, crows and blackbirds. Apparently, the real pests were other animals. A few years later, in 1716, a bill was brought before the assembly to encourage the killing of foxes and wild cats on Long Island.

BELIEVE IT OR NOT, STORMY WEATHER

In early July 1756, a violent storm ripped through Queens County. It was called a hurricane in reports of the time, but was more likely a severe tornado or line of tornadoes. Reports described the massive destruction: uprooted trees were everywhere, and large limbs weighing more than 100 pounds were thrown distances of two thousand feet. Homes were damaged and six barns were destroyed. A total of eight hundred apple trees were completely destroyed. A 150-pound grindstone was picked up and thrown fifteen feet. One barn was completely shattered into countless pieces and its heavy iron hinges wound up about a quarter-mile away. Two apple trees were completely lifted from the ground and thrown thirty rods. Damages were estimated at £2,000 to £3,000. The whole thing was over in a matter of minutes. The report of the event in a New York City newspaper said, "Doubtless some persons will be surprised, and others ridicule this relation."

STAY HEALTHY ON SHELTER ISLAND

In 1845 there were eleven physicians in the town of Southampton, nine in the town of Southold, five in the town of Easthampton, three in the town of Smithtown, one in the town of Islip and none on Shelter Island.

MARRY A QUAKER AT YOUR OWN PERIL

In February 1684, William Hollyoake of Southold signed his will before five witnesses. In the document, he provided generous plots of land for his sons. However, he warned that if any of them strayed from the Protestant faith or doctrine, failed to attend Sunday worship or married a Quaker, they would be "utterly disinherited and disowned. And I bequeath the lands so forfeited by such wicked practices, to the next lawful heir."

A SANDY CURE

During the 1870s, the beach at Fire Island was known for its curative properties. It was said that a sand bath there could cure rheumatism. The patient would be carried to the water's edge at low tide, a few feet from the surf. A hole would be dug, and the patient would remove his clothes. Then he would get into the hole and be completely covered in sand except for his head and right arm. This was said to cause tremendous sweating, such that nobody could withstand more than fifteen minutes of treatment. However, after emerging, it was reported that all patients were miraculously cured. One sixty-year-old man who could hardly move beforehand was said to feel light and springy, and wished to skip like a kid after the sand treatment.

p. 57 - sleep

Visit us at
www.historypress.net